Fresh Ideas in Limited Budget Design. Copyright © 1998 by North Light
Books. Manufactured in Singapore. All rights reserved. No part of this book
may be reproduced in any form or by any electronic or mechanical means
including information storage and retrieval systems without permission in writ-
ing from the publisher, except by a reviewer, who may quote brief passages in a
review. Published by North Light Books, an imprint of F&W Publications, Inc.,
1507 Dana Avenue, Cincinnati, Ohio 45207. (800) 289-0963. First edition.

This hardcover edition of *Fresh Ideas in Limited Budget Design* features a "self-
jacket" that eliminates the need for a separate dust jacket. It provides sturdy pro-
tection for your book while it saves paper, trees and energy.

Other fine North Light Books are available from your local bookstore, art sup-
ply store or direct from the publisher.

02 01 00 99 98 5 4 3 2 1

Library of Congress Cataloging-in-Publication Data

Newberry, Betsy.
 Fresh ideas in limited budget design / by Betsy Newberry. — 1st ed.
 p. cm.
 Includes index.
 ISBN 0-89134-840-9 (alk. paper)
 1. Commercial art—Themes, motives—Catalogs. 2. Graphic arts—
Themes, motives—Catalogs. I. Title.
 NC997.N42 1998
 741.6'075—dc21 97-32094
 CIP

Edited by Kate York
Production edited by Bob Beckstead

Acknowledgments

The assistance and hard work of many people helped bring this book together. I'd like to thank Patricia Gallagher Newberry, who helped me research and write descriptions for many of the projects featured. I'd also like to thank Kate York at North Light Books for organizing the vast amount of material we received from designers all over the world. Her foresight, planning and attention to detail made my job much easier. I also owe thanks to Lynn Haller at North Light for involving me in this project. Last, thanks to my husband, Jon, for putting up with the whining and complaining that often accompanied those long hours late into the evening behind the computer.

About the Author

Betsy Newberry is a Cincinnati-based writer specializing in business and design topics. She is the author of *Fresh Ideas in Promotion 2* and *Designer's Guide to Marketing*. She has been writing about the design industry for more than twelve years and is a frequent contributor to *HOW* magazine for graphic designers. She's also authored and edited a number of computer training tutorials and textbooks for the high school and post-secondary school markets.

Table of Contents

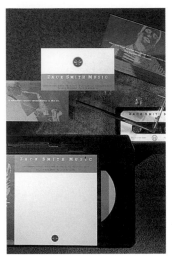

Posters

Big things come in small packages, or in this case, big things can be achieved with a small budget. These posters illustrate the big picture and yet some were produced for a pittance.

Page 91

Pro Bono

Contributing design work pro bono can have big business payoffs, not to mention personal rewards. These projects illustrate wonderful design for worthy causes.

Page 105

Miscellaneous Pieces

See how designers implemented a variety of cost-saving measures in creating these fascinating and unusual pieces, including menus, packaging, signage and books.

Page 123

Introduction

Doing more with less is the norm rather than the exception these days. You probably can't remember the last time a client told you to spend whatever you needed to design a fabulous brochure or a dazzling identity system. As one designer laments, "When a client calls with a job, the budget is always either the first thing they bring up or the last thing they say before saying good-bye."

That's where a little know-how and *Fresh Ideas in Limited Budget Design* come into play. You're going to hear more and more clients complaining about costs and pulling on the reins when it comes to high-priced design solutions. But knowing the ins and outs of getting what you and the client want for a reasonable price can make you look like a genius.

Meeting the challenge of designing on a limited budget doesn't mean you have to limit your creative talent. Just ask Rossana Lucido of Timbuk 2 Design in Upland, California. She says her studio has carved out a niche in the low-budget design market. The studio even puts its self-promotional materials on a tight budget to show clients how simple inexpensive two- and three-color projects can still be powerful marketing and communication tools.

Knowing Where to Cut Costs

A limited-budget project also doesn't mean you have to shave the prices you charge for your creative talent, as evidenced by the more than 120 design projects showcased in this book. In fact, if you find you can't get the job done within the budget allocated and without cutting creative costs, then taking on the project is probably not a wise business decision. It takes a lot of discipline to stand firm on the fees you charge for your services. But if you are equally creative in utilizing other cost-saving measures—as the design studios featured in this book have demonstrated—you won't find yourself constantly forced to evaluate the financial ramifications on your business of taking on a limited budget design project.

Small design studios on average find that a third of a project's budget is allocated to creative time. Another third typically covers printing costs. The final third goes toward prepress production costs, including photography, illustration, copywriting and general project management services.

The majority of projects featured on the following pages have utilized a variety of measures and techniques to

control that 60 to 70 percent of costs associated with printing and prepress production, while leaving creative fees virtually untouched.

Try Your Hand at Bargaining

Many designers find that building and nurturing relationships with vendors, including printers, paper suppliers and film houses, can put them in a good position to request discounts or to bargain for special deals when a tight-budget job comes up.

Getting Services Donated

- Build good relationships with printers, paper suppliers, etc.
- Exchange your design talents for freebies or discounts.
- Use your network contacts to solicit the talents of photographers, copywriters and illustrators who are anxious to get their work seen.
- Give lots of credit on the printed piece to those who helped out.

Present the piece to your rep and explain the reason for the limited budget. Many will donate paper or printing in exchange for a mention on the piece. Many printers and paper mills are willing to donate their goods and services to reputable nonprofit organizations. Some do it for tax purposes and others do it out of the goodness of their hearts. Kiku Obata & Company in St. Louis, Missouri, for example, used donated paper for an invitation for the St. Louis Easter Seal Society. The printer and the paper used were noted on the inside back cover of the invitation, which was distributed to a wide range of supporters in the community.

Hal Apple Design & Communications, Inc. in Manhattan Beach, California, got Heidelberg USA to contribute the printing for a four-color brochure in exchange for a credit line on the back cover and use of the piece to showcase their printing equipment capabilities and expertise on complex printing jobs. The piece was a brochure for a color separation house (see p. 18). Heidelberg would run the brochure when demonstrating their press and distribute it to

potential clients to promote their services and expertise. This added exposure was a benefit to Apple and the color separator as well.

And Scott Hull Associates in Dayton, Ohio, worked out an arrangement with a printer to produce a self-promotional calendar free of charge in exchange for a similar calendar design for the printer (see p. 70). The final product is a classy, functional piece that looks like it cost thousands of dollars to produce.

In addition to printers and paper suppliers, you can also tap other resources to donate services. Photographers, illustrators, copywriters and color separators, for example, are always looking for exposure for their work. If you can find the right match between their capabilities and the audience for the piece you're designing, it's normally to the supplier's advantage to contribute. De Vale Design in Chicago, Illinois, produced a sophisticated set of postcards distributed as New Year's gifts to clients and potential clients (see p. 90). The six cards included in the set feature striking photos that were donated by the photographer in exchange for a credit line on each card and free copies of each to use for his own portfolio.

Louey/Rubino Design Group Inc. in Santa Monica, California, solicited artwork from school children across the state of Arizona to use in a twenty-four-page Report to the Community published by The Trust, a nonprofit agency that provides playgrounds, field trips and other extracurricular activities to Arizona public school children. The children's artwork was featured prominently in the book (see p. 121). In addition, the designer replicated colors in the artwork throughout the annual report for type and backgrounds. The report was such a hit that The Trust's board increased the print run from one thousand to five thousand and scrapped plans to produce a separate capabilities piece in favor of using the report. In addition, the artwork created for the report was saved for a traveling exhibit in Arizona.

And, don't forget to put your clients to work. Give them the responsibility of editing copy and finalizing any changes before they hand over the job. Make sure they provide all copy on disk. Get them to gather possible artwork and photos that can be used in the piece, and to get permissions to use it, if necessary. Delegate as much of the job as you feel comfortable doing, because fifteen minutes here and fifteen minutes there can quickly add up to hours of

time you should be spending on design and creative work.

The Economics of Paper

Paper suppliers and printers might also suggest you use in-stock papers or leftovers from canceled jobs or orders to control costs. Printers often maintain large inventories of certain types of papers. It's more cost effective to print a job using paper that's readily available rather than having to order something special. Also, many printers have "scraps" of paper—some very exotic and pricey—left over from other print jobs laying around that they'd just as soon give away as opposed to throwing away. That way, they can avoid any recycling or waste management costs that might be incurred.

Getting the Most Out of Paper

- Use in-stock or leftover paper from canceled printing jobs from the printer.
- Ask for "scraps" of nice paper left over from other jobs; or collect the trim from other print jobs.
- Optimize paper use by configuring the piece on the paper sheet in the most economical way. Utilize all space on the sheet, if you can.
- Buy paper and printing in the largest quantity possible.

Images Graphic Design, a studio in Grafton, Vermont, created a one-of-a-kind birthday card using paper scraps left over from previous jobs (see p. 54). A few different papers of varying colors and textures were layered and assembled to create a unique and very inexpensive piece. After Hours Creative in Phoenix, Arizona, also utilized paper from a canceled print job to produce an invitation that looks much more high-budget than its actual 90 cents per piece cost (see p. 53). The rich 80# cover stock used is instrumental in establishing that look for the piece. And, Get Smart Design Company in Dubuque, Iowa, was able to control costs on a self-promotional greeting card by using a paper stock the

printer had on hand (see p. 73). The two-toned paper stock is unusual and might not be a common selection for most print jobs. Paired with a thoughtful design concept, though, it helps the whole presentation sparkle.

Another way to control paper costs is to consider printing as much quantity as possible, thus lowering the price per unit. As you know, the quantity of the press run often has a bearing on the grade of paper you select. Regardless of the complexity of the job or the quality of the paper, you should always get quotes on printing two or three different quantities. You might find a price break at a certain level, which could have a significant impact on the price per unit cost.

Also, keep in mind the ink coverage required by the design. If the coverage is heavy, you can get by with a lesser-quality paper that will be camouflaged by the color and intensity of the ink. If the coverage is light and you're relying on the paper to help communicate the message, then you'll probably want to invest in a higher quality stock.

You can also control paper costs and optimize paper use by configuring the piece on the paper sheet in the most economical way. Maximizing the sheet and eliminating paper waste cannot only stem costs, but it can also present you with opportunities for producing additional pieces for the same job, or even for a different job, for a minimal amount of money. For example, Joe Miller's Company in Santa Clara, California, incurred no out-of-pocket costs for a bookmark that was included with a series of announcements for artist exhibitions sponsored by the Works/San Jose (see p. 57). The one-color bookmarks were printed on the trim of the sheet of an unrelated job, and represent a functional addition to the card promotions.

Timbuk 2 Design was also able to utilize leftover sheet space to add another piece to its own holiday promotion. The promotion consisted of a thoughtfully designed set of holiday cards and envelopes (see p. 82). A 20"x 26" (50.8cm x 66.0cm) sheet size accommodated the four different holiday cards. The designer used leftover sheet space for six small holiday name tags. Out-of-pocket expenses incurred for the job totaled $450, with only $250 of that in printing costs.

Another clever technique for getting the most use out of a press sheet is exhibited in a versatile self-promotional package developed by aire design company in Tucson, Arizona. The project is composed of three elements: postcards, a calendar and a poster. Twelve postcards, some of which feature the studio's past projects while others are more abstract and personal, were printed as a poster unit.

The postcards were arranged in a block and key words characterizing the studio were placed on the poster to balance the presentation. Some of the posters were cut into individual postcards, which were then placed as inserts on the one-color calendar pages. Clients could easily remove them and still have an attractive calendar page—featuring a one-color screened version of the naturalistic calendar cover design—to look at. The calendar cover was ganged on the same sheet as the poster. The budget for the promotion was $5,000. Actual costs were just over $3,000.

Experiment With Alternative Printing Methods

Printing costs represent a sizable chunk of any design project. Depending on the nature of the project and the audience to whom it will be distributed, though, you have lots of options for limiting this expenditure, and lots of opportunities to experiment with different methods that produce widely varying effects.

Many design projects—especially those with quantities of a thousand or less—are ideal candidates for printing alternatives, such as laser and digital printing and high-quality color copying. In fact, many of the projects featured in this book were generated on in-house laser printers! And, it's highly unlikely the intended audience for most of the pieces knew enough about any printing method to recognize they were printed using very inexpensive procedures.

Controlling Printing Costs

- For smaller jobs, use laser and digital printers.
- High-quality color copies can help save a bundle.
- Using a "Z" fold when appropriate keeps printing to one side only.
- Gang up several pieces from a project on one sheet.

Knuckle Sandwich, a Phoenix-based studio, designed a logo and stationery system for a cigar club, all of which could be reproduced directly on a 600 dpi laser printer (see p. 39). The only real cost, according to designer Steve Ditko, was approximately $10 for photocopying and materials, including 200 letterhead, 200 cigar rating forms, 50 folders and 500 stickers.

Lo Schiavo Design Group, based in São Paulo, Brazil, also developed a studio stationery system that included many one-color pieces that could be printed in-house using an ink-jet printer and inexpensive paper (see p. 47). Paired with a business card that's printed on similar paper and features a cutout of the icon used in the logo, the overall presentation is slick and professional looking.

Hal Apple Design found that the super high-quality prints from a Canon Fiery copier would suffice for the studio's holiday greeting card it sent to friends and clients (see p. 80). And designer Rick Tharp of Tharp Did It, Los Gatos, California, generated a blueprint of the studio's corporate identity work that could be readily updated at a relatively low cost (see p. 78). The process involved making photostats or photocopies of the logos, pasting them into position, and then generating a blueprint. The blueprints are so inexpensive (about $1.50 each) that the studio can keep a supply on hand and send them to potential clients at a moment's notice.

Also, printing only one side of the sheet on press will greatly reduce the cost. Try a "Z" fold to get the maximum space for copy and graphics while printing only one side.

Color It Rich

One- and two-color designs are significantly less expensive and usually more practical than four-color printing for those projects on a tight budget. Giving a limited budget design project the illusion of a high budget can easily be accomplished through the skillful use of color and other special touches. One obvious technique for adding color to a job is by printing on colored, speckled or heavily textured paper.

Smart Works Pty Ltd, located in Melbourne, Australia, developed a stationery system using two PMS colors. The

Getting More Color for Less

- Add additional colors to small jobs by hand or with a stamp.
- Turn a two-color job into three by taking advantage of the huge array of paper colors now available.
- Use tints to extend your color range without adding the cost of another color.

use of a rich mulberry-colored duplex board introduced a third color to the design range (see p. 22).

Doink Inc., a studio in Coral Gables, Florida, came in under its $3,000 budget for an annual report-type book created for the South Florida Hospital & Healthcare Association. The designer relied on tints of the two PMS colors and black to provide more color variation and to create the appearance of more color.

Getting Special Effects

- Use stickers, stamps, wax seals, string, found objects, etc., to create interest.
- Apply marker to small jobs for extra colors.
- Have the client's staff or volunteers apply the special elements — a very cost-effective solution.

Add Low-Cost Special Touches

You can add color and interest to a job through other low-cost special touches. Experiment with stickers, stamps, existing art and photos, labels and found objects. The possibilities are endless.

For the studio's Christmas card, Eric Kass Design in Fishers, Indiana, laser-printed the message in black on a neutral-toned stock, cut out the message and affixed it to a piece of chipboard that was originally used as packing material. Dates were then stamped on the card using red and blue ink (see p. 85). Rubber stamping the dates on the card gave it a personal touch while adding low-cost color. To top it all off and add more color, the designer chose a showy Santa Claus stamp for mailing the card. The total cost for the promotion was a little over $10.

The designers at Albuquerque-based Kilmer & Kilmer, Inc. added color and interest to the chipboard cover of their corporate brochure by simply cutting out the studio's logo from old business cards and gluing it to an imprinted square shape on the cover.

And, Toni Schowalter Design, a studio in New York City, accentuated the bright red cover of its Valentine's Day greeting card with a single metallic red heart sticker applied individually to each card by the studio staff. The sticker shape served as the model for other "heart art" used throughout the multipage card.

Bargain Basement Assembly

Folding, binding and assembly costs for a design project can quickly add up and even catch you off guard if you don't plan ahead. But this is another area where the savvy designer can save costs, stretch the budget dollar and achieve some fascinating results.

Fresh Design in Brentwood, Tennessee, crafted a mini-portfolio consisting of numerous 7¼-inch (18.4cm) square inserts, which are bound by two screws in a heavy stock folder (see p. 87). The portfolio was assembled by hand and projects a sophisticated, industrious image of the studio.

The staff at Oakland, California-based Canary Studios developed an unusual self-promotion consisting of three boxes, each containing doodads and a special message about the studio's capabilities (see p. 81). To save costs, the boxes were printed in one color and utilized the same die. Staff members assembled the boxes and were able to complete the promotion at $500 under budget.

And Sayles Graphic Design in Des Moines, Iowa, got volunteers to help assemble a lively invitation to an event celebrating Latin American culture (see p. 56). The invitation consists of four cards, each cut at different angles, and a piece of burlap, that are hole-punched and bound with heavy brown twine. A cinnamon stick is also bound with the chipboard and burlap. The invitation was delivered in a muslin drawstring bag. The presentation as a whole is highly interactive and tactile, but not high cost.

Cost-Saving Mailing Techniques

Many of the projects profiled in this book relied on standard formats to keep from incurring any significant assembly or mailing costs. Postcards were a popular choice for invites and announcements. And, many brochures were formatted as self-mailers to eliminate the additional costs of envelopes and envelope printing. White Design in Long Beach, California, for example, devised a charismatic self-mailer to announce the opening of the Latin American Art Museum (see p. 25). The piece also doubles as a rack brochure. The format allowed the designer to spend more of the budget dollars on highlighting the bold, vivid colors associated with the art featured at the museum.

When envelopes were part of the design, many studios wisely sized the piece to fit standard-size envelopes. They then dressed up the envelopes with stamping or stickers instead of traditional envelope printing methods.

In developing a clever, offbeat identity system for one of their clients, Zimmermann Crowe Design in San Francisco, California, was able to save costs by using standard manila envelopes printed with one color. The basic treatment of the envelopes was a suitable, cost-effective complement to the rest of the two-color system (see p. 37).

Conclusion

As you'll discover as you read through the pages of this book, limited budget does not mean limited design or limited creativity. In fact, working under tight budget constraints appears to bring out the creative, problem-solving genius in many designers. And, that's a key in selling your services and talents to clients. Just ask Penny Morrison of Morrison Design & Advertising in Houston, Texas.

Her studio created a modest, low-key holiday gift promotion that sends a strong message to clients about the studio's attention to finding innovative, cost-effective solutions to their design needs (see p. 79). Utilizing leftover laser copies and waste paper from various projects completed by the studio, the designers assembled spiral-bound notebooks that clients could use for jotting notes and doodling. The copies were cut smaller and assembled with the blank side up. On the flip side, recipients get a sampling of the studio's capabilities and range of design skills, as represented by the snippets and fragments from various design projects. A thank you/explanation message is inserted as the first page in the book while a business card is bound in the back.

"We like to give them [clients] things they can use," Morrison says. "[We] vary our gifts every year, keep costs low. We specialize in finding innovative, cost-effective avenues for getting the message across. This is how we sell ourselves. Talk the talk, walk the walk."

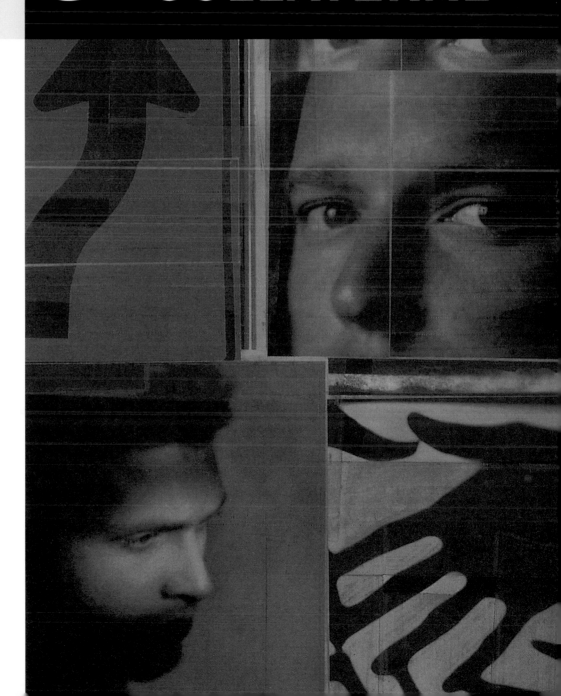

BROCHURES
& BUSINESS
COLLATERAL

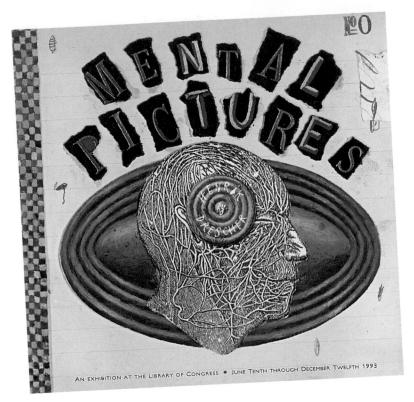

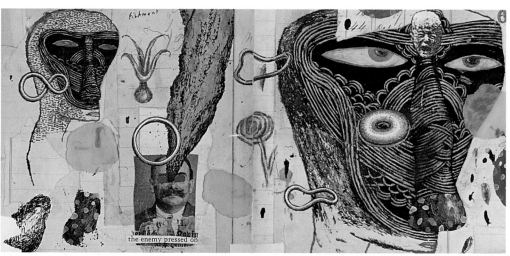

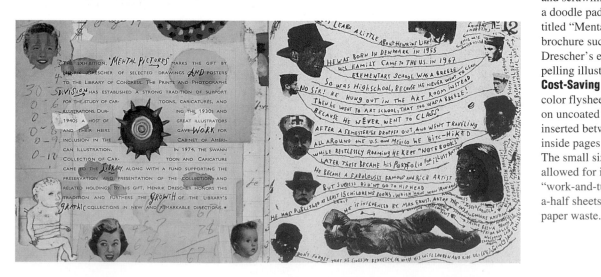

Henrick Drescher Exhibit Brochure

Art Director/Studio Judy Kirpich/Grafik Communications, Ltd.; Henrick Drescher
Designers Judy Kirpich, Julie Sebastanelli
Illustrator Henrick Drescher
Client/Service The Library of Congress/Public library
Paper Xerox bond, Vintage Velvet
Colors Four-color process for section printed on Vintage Velvet, two-color for photocopied flysheet
Typefaces Futura, hand-lettering
Printing Offset on Vintage Velvet; Xerox copies of flysheet

Concept Good things come in small packages as evidenced by this 5¼" x 5" (13.3cm x 12.7cm) brochure showcasing the work of illustrator Henrick Drescher. The piece was commissioned by the Library of Congress to commemorate Drescher's donation of a collection of illustrations. The designers worked closely with Drescher to create a piece that reflects his knack for communicating thoughts and ideas through the careful intertwining of figures and words with signs and symbols. Drescher refers to his work as a "junkyard of the imagination." Each page of the eight-page brochure is crammed with such "junk," ranging from postage stamps and figures written on a legal pad to drawings and scrawlings you might see on a doodle pad. Appropriately titled "Mental Pictures," the brochure successfully captures Drescher's energetic and compelling illustration technique.

Cost-Saving Techniques A two-color flysheet was photocopied on uncoated bond paper and inserted between the cover and inside pages of the brochure. The small size of the brochure allowed for it to be printed "work-and-turn" on one-and-a-half sheets and eliminated paper waste.

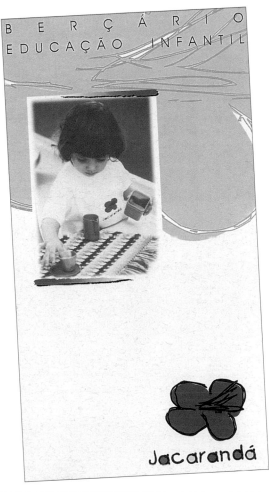

Jacaranda Preschool Promotional Folder

Art Director/Studio Vicente Lo Schiavo/Lo Schiavo Design Group
Designers Dino Vettorello Filho, Gaston Lefebvre
Client/Service Jacaranda Preschool/Preschool
Paper Simpson Sundance Navajo White
Colors Four-color process
Typeface Comic Sans
Printing Offset
Cost $.79 per unit

Concept The naturalistic and anthropogenic scope of this Brazilian preschool served as the inspiration for the design of this promotional brochure. Measuring 6¼" x 11¾" (15.9cm x 29.9cm), the two-fold piece relies on serene photos of preschool children paired with a simple flower illustration (that also serves as the school's logo), to communicate the institution's emphasis on the peaceful coexistence of humans and nature. The flower illustration is reproduced in varying shades of soft purple and pink. The primary colors of red, blue and yellow are incorporated as part of the school's name and add a touch of elementary, childlike charm to the piece.
Cost-Saving Techniques The piece uses black-and-white photos and recycled paper.

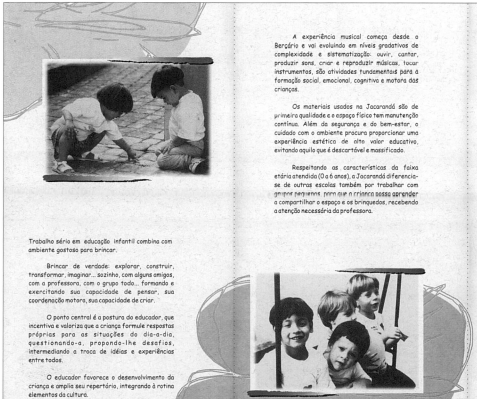

Wexner Center Membership Direct Mail

Art Director/Studio Terry Alan Rohrbach/Wexner Center for the Arts
Designer Terry Alan Rohrbach
Photographers Chas Krider, Kevin Fitzsimons
Writers Jennifer Boyd, Roger Addleman
Editor Ann Bremner
Client/Service Wexner Center for the Arts/Arts and cultural institution
Paper 100# Repap Matte Text; 60# offset; 80# Repap
Colors Four-color process plus a varnish
Typefaces Base Nine, Courier, Helvetica
Printing Sheetfed, offset
Cost $.36 each piece; $.40 budgeted

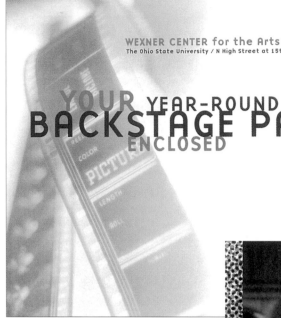

Concept As a way to entice people to join the Wexner Center arts and culture institution and to promote an exhibition of art and film works, the designer fashioned this direct-mail piece like an invitation to a backstage film party. The exhibition, titled "Hall of Mirrors: Art and Film since 1945," explored the connection between movies and visual art. It featured the work of Andy Warhol, Edward Hopper, Alfred Hitchcock, Diane Arbus, Martin Scorsese and more. The direct-mail piece consists of a cover letter and business-reply envelope, a four-page brochure measuring 5½" x 8½" (14.0cm x 21.6cm), and a four-color perforated reply card. One part of the card is a membership form recipients could mail in with membership dues; the other part is a "backstage pass" new members could use to attend the Hall of Mirrors preview party. Both the brochure and reply card feature film-related images—a movie theater audience, a young couple "making out" as other moviegoers wearing 3D glasses look on and grainy enhancement of photos to replicate the look of old newsreel footage.

Cost-Saving Techniques Image editing, including the conversion of photos to duotones and general edits, were done in-house to avoid costly vendor fees. All proofing was completed prefilm. Printer suggested lower-priced papers and determined the most efficient press configuration.

Special Visual Effect Four-color process used to produce high-contrast duotones.

Special Production Techniques Images were colored in Photoshop as duotones and then converted to CMYK files. Color channels were adjusted to match the intended effect.

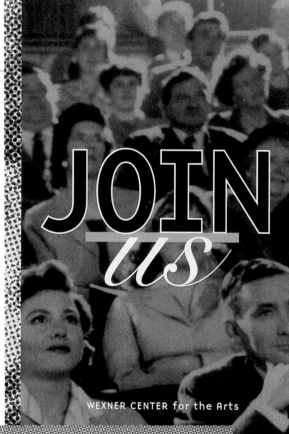

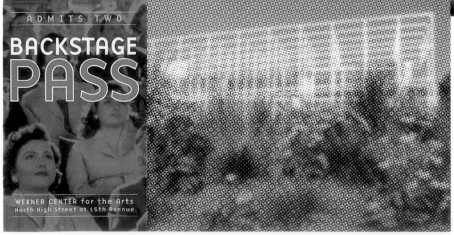

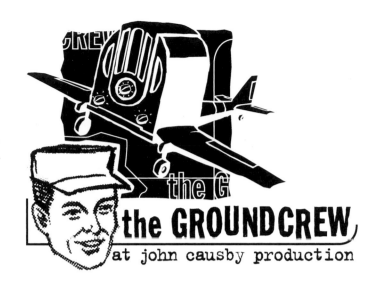

The Groundcrew at John Causby Production Logo and Brochure

Art Director/Studio Patrick Short/BlackBird Creative
Designer Brandon Scharr
Illustrator Brandon Scharr
Writer Patrick McLean
Client/Service The Groundcrew at John Causby Production/Full-service broadcast production house
Paper French Butcher White, Chipboard
Color Black
Typeface Trixie
Printing Offset
Cost Printing cost was $1,750. Dog tags and pouches were supplied. Creative time was traded for studio time.

Concept When your client is known for his willingness to do anything to make his customers happy, it might be difficult not to succumb to a warm, fuzzy design concept for promotional materials. But the designers of this promotion resisted. They created a piece that equates their client's commitment to customer service and satisfaction with the dedication and motivation of World War II ground crew mechanics. John Causby assembles voice-overs, music and other audio for broadcast. His clients praise him for not only his quality technical work, but also for being willing to go above and beyond the call of duty to meet their needs, even if it means making them cappuccino. This reminded the design team of the World War II ground crew mechanics who worked hard, often laboring through the night, to get the planes in the air and the job done. The designers created the "Official Ground-crew Handbook" brochure to reflect the look of a mechanic's log or handbook. Black-and-white photos of actual ground crews are interspersed with typed entries that describe not only Causby's services, but the responsibilities of those famous ground crews as well. The presentation was purposely pro-

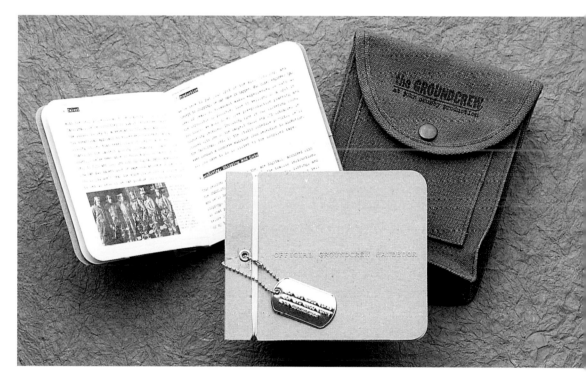

duced to be rough and utilitarian in nature. A dog tag with Causby phone numbers is attached to the brochure, which is bound with a rubber band and housed inside an army surplus ammo pouch. A CD containing talent selections is inserted in the back cover of the brochure.

Cost-Saving Techniques The designers used government stock photography at no cost. Die for the brochure was specially engineered to hold the CD so an additional holder was not

necessary. The paper company donated chipboard used for the brochure cover.

Special Visual Effect The French Butcher White paper created an old and worn feel for the brochure, which further supported the concept.

Special Production Technique A rubber band was used as a binding for the book, again reminiscent of how a log might be bound.

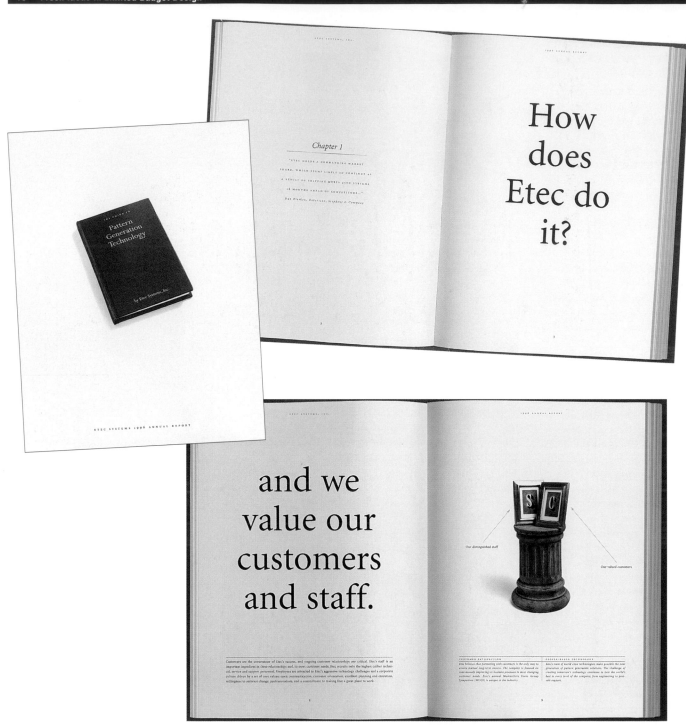

Etec Systems, Inc.
1996 Annual Report

Art Director/Studio Bill
Cahan/Cahan & Associates
Designer Lian Ng
Photographer Tony Stromberg
Client/Service Etec Systems,
Inc./Pattern generation technol-
ogy supplier
Paper Mohawk Vellum
Colors Four-color process
Typeface Minion
Printing Offset
Cost $1.10 per piece

Concept Etec is the industry
leader in mask pattern genera-
tion. To intimate that Etec
"wrote the book" on this tech-
nology, a mock-up of a book
titled "The Guide to Pattern
Generation Technology" with
Etec listed as the "author" was
placed on the front cover. The
rich bronze color of the book
cover contrasts sharply with the
bright white cover stock. A

shadow behind the book creates
depth, encouraging the viewer
to open its front cover. The
book theme is maintained
throughout the annual report
with each spread designed to
look like an inside spread of a
book.
Cost-Saving Technique The
designers used only three
images to simulate the pages
of a book.

Special Visual Effect Bowing
and curving the imaged pages
created the same look and
dimensionality as the pages
of an actual book.

Dealing with Disaster Seminar Announcement

Art Director/Studio Andrea Rutherford/Smart Works Pty Ltd
Designer Andrea Rutherford
Client/Service International Association of Arson Investigators/Professional association
Paper Silk matte
Colors Black, PMS 130 yellow, PMS 188 red, and varnish
Typefaces Univers, Garamond ITC
Printing Offset, sheetfed
Cost 2,500 brochures and 2,000 flyers (not shown) cost $.83 per unit. Design costs were $950, production and film costs were $960 and printing costs including 22 percent tax were $1,830.

Concept Creating a provocative seminar brochure was a challenge for the designers, who were provided with only the copy and three poor-quality photos of disaster scenes. The seminar, entitled "Dealing with Disaster," was open to any professional involved in the field of disaster management. Although the supplied photos of disaster scenes were startling, the designer opted to make them a secondary element on the brochure's cover. A striking photodisc image of what appears to be a piece of wreckage takes center stage. Vivid gold and burgundy colors reinforce the intensity of the seminar theme, as does the special type treatment of the word "disaster."

Cost-Saving Techniques To save on design and production costs, artwork for the flyer was created with minor text modifications. The same art was used for the cover of the seminar brochure. This cut down the client's costs considerably.

Special Visual Effect A fake duotone was used on the cover to create depth, but also to save on duotone tests.

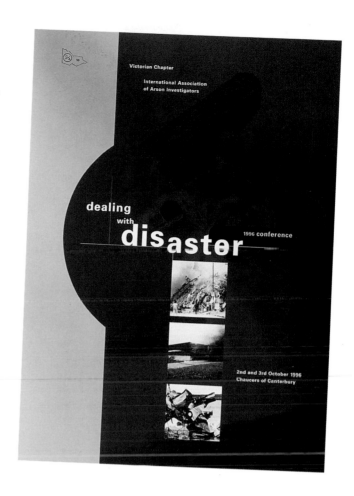

Ideal Graphics Brochure

Art Director/Studio Hal Apple/ Hal Apple Design & Communications, Inc.
Designer Andrea Del Guercio
Photographers Jason Ware, Tracy Lamonica, Jesse Chen, Juni Banico, Juan Lopez
Client/Service Ideal Graphics/ Color separator and film house
Paper Karma Matte White 100# cover
Colors Four-color process, plus two match and a varnish
Typeface Futura
Printing Offset
Cost $2.50 per piece

Concept Graphic designers are bombarded with loud promotional materials from color separators, film houses and other suppliers that tend to look the same after a while. So when Hal Apple Design was charged with creating a capabilities brochure for a film house to be distributed to graphic designers, the design team had a pretty good idea of what not to do. The designer, instead, chose a straightforward approach that simply showed the audience what Ideal Graphics could do. Riveting full-page photos complemented with minimal copy illustrate Ideal Graphics attention to detail and quality. The captivating presentation is strengthened by the

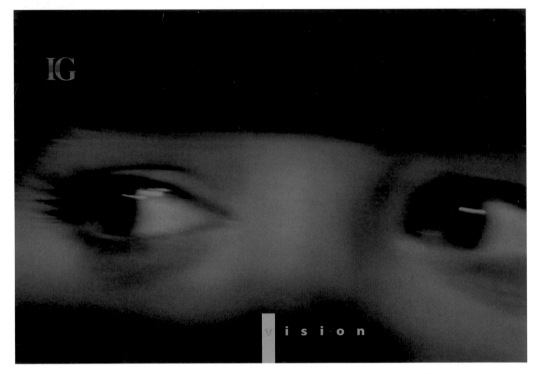

unusual 11" x 7" (29.2cm x 19.1cm) dimensions of the eight-page booklet.

Cost-Saving Techniques

Printing was contributed by Heidelberg USA to showcase their equipment capabilities and expertise on complex printing jobs. In addition, Heidelberg would run this piece when demonstrating their press. Separations were created by the client, and photography was purchased at nominal fees or donated in exchange for printed samples and credits to all photographers. Once the brochure was laid out on the process sheet, Ideal Graphics discovered there was enough sheet left to print note cards, business cards and the world's smallest brochure. These pieces, too, were designed by Hal Apple Design and contributed to a well-rounded promotional system that is enjoyable for the Ideal sales team to use and for potential clients to receive.

Special Production Techniques

Used a spot match varnish, a metallic ink and a fifth color (rubine) added to the four-color process to add depth and brilliance to the reds.

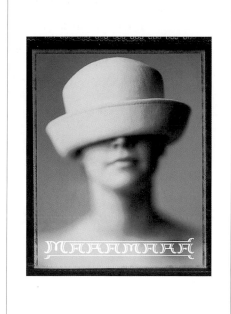

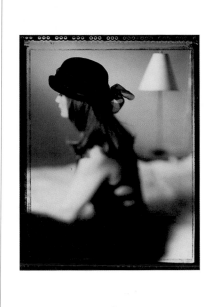

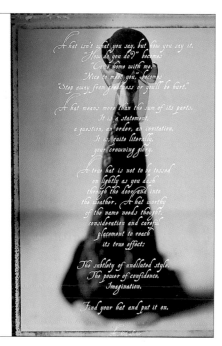

Maramara Catalog

Art Director/Studio Carlos
Segura/SEGURA INC.
Designer Carlos Segura
Photographer Jeff Sciortino
Copywriters Jim Marcus, Anna
McCalister
Typeface Design Jim Marcus/
T-26
Client/Service Maramara
Millinery Design/Milliner
Paper Signature Gloss Cover
80# for cover, Signature Gloss
Text 100# for inside pages
Colors Black
Typeface Aquiline
Printing Offset

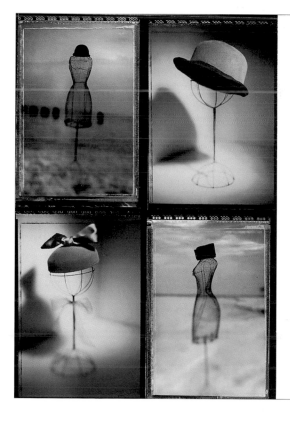

Concept There's just something
about a hat. Or, in the words of
the designers of this twenty-
two-page brochure-cum-catalog
for Chicago hatmaker Mara-
mara, "A hat means more than
the sum of its parts. It is a state-
ment, a question, an order, an
invitation. It is, quite literally,
your crowning glory." The glo-
ries of Maramara are illustrated
in page after page in this 5" x 8"
(14.0cm x 20.3cm) book, with
the camera focused on the hats
and blurring much of the rest of
the model or image. Framed to
look like film negatives, the
photos resemble candid snap-
shots in which the hats match
the personality of their wearers.
Calligraphy-style type com-
pletes the look of the book,
offering short essays on hats
and the people who wear them.
Cost-Saving Technique The
models donated their time in
exchange for custom-made hats.
Special Visual Effect Rack-
focus photography puts the
focus on the hats.
Special Production Technique
Use of duotones creates an old-
world feel to the photography.

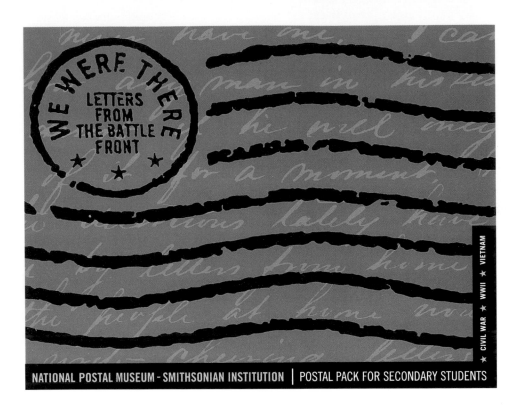

WE WERE THERE LETTERS FROM THE BATTLE FRONT

★ CIVIL WAR ★ WWII ★ VIETNAM

NATIONAL POSTAL MUSEUM – SMITHSONIAN INSTITUTION | **POSTAL PACK FOR SECONDARY STUDENTS**

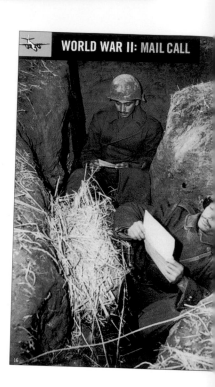

WORLD WAR II: MAIL CALL

We Were There: Letters From the Battle Front Booklet

Art Director/Studio Claire Wolfman/Grafik Communications, Ltd.
Illustrator Joe Barsin
Client/Service The National Postal Museum/Part of the publicly funded Smithsonian Institution
Paper Matte finish, 100# text
Colors Three PMS on cover and two PMS inside
Typeface Trade Gothic
Printing Offset lithography

Concept As a commentary on letters and postal history from three American wars distributed to secondary school students, this forty-four-page booklet tastefully conveys a patriotic message while capturing the attention of the "MTV" generation. On the cover, a cancellation stamp that's skillfully manipulated into a graphic representation of the American flag sets a more contemporary tone for the piece. The contemporary theme is further supported through the use of a sans serif font. The inside pages are domi-

THE CIVIL WAR: LETTER 1 [continued]

Photograph of Confederate soldier, Albert Hall

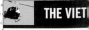

LETTER 1: TRANSCRIP

Camp 27th NO. CA. INF'Y
March 8th 1865

My Dear Mother

THE VIET

Vietnam was a part French in 1954. The West. By 1969, more than defoliants, and other advance strongly motivated enemy.

This was the first war in Am Rights Movement was gaining the struggles both on the ba

nated by large photos of soldiers on the battlefront and reproductions of letters they wrote and received. Copy on postal history is limited to short, digestible snippets of information. To underscore the military theme,

the designer used drab olive, black and gold colors.
Cost-Saving Techniques The cover utilizes three colors but only two are used for the inside. Images and photos were supplied by the Postal Museum.

WORLD WAR II: EX POST FACTO

The Second World War was fought across six of the planet's seven continents and in all of the oceans. The war effort included the involvement of over 16 million American men and women. The United States supplied its own armed forces and manufactured huge quantities of war material for its British and Russian allies. American factories produced 100,000 tanks, 274,000 military aircraft, 41 million rounds of ammunition, and 55 million tons of merchant shipping.

Communicating with families and friends was a great morale booster for the men and women stationed around the world. But transporting mail across a world at war was fraught with obstacles. The Post Office Department used a new technology, V-Mail, to deliver enormous amounts of mail vast distances.

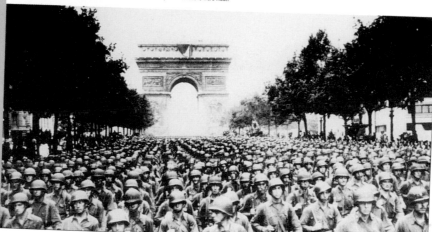

WHAT'S DIFFERENT BETWEEN THIS STAMP AND THE PHOTO BELOW?

This stamp was released on September 28, 1945, to honor the U.S. Army. The photograph depicts the 28th Infantry Division marching through Paris on August 29, 1944. General George C. Marshall is credited with selecting this photograph to be made into a stamp. How is the stamp the same yet different from the photograph? Marshall came up with the idea of adding six bombers to the picture even though there were no bombers present at that particular moment. Because this stamp was meant to honor the entire U.S. Army and the Army Air Corps which had made a crucial contribution to the war effort, special alterations were made.

WHAT DO YOU THINK?

1. On which side did Capt. Graham fight? How much fighting has the letter writer experienced?

2. According to Graham, what is the cause of the troops' desertion? Why was this form of communication so powerful? In his opinion what might prevent the soldiers from deserting?

3. What thoughts did Lincoln express about slavery in his second inaugural address?

4. Class Discussion: What are the responsibilities and commitments of a soldier? Should a soldier continue fighting for a losing cause?

tines yet, and I am beginning to think that we or Sherman & Co. to develop their plans fully before

I hope they will soon be all right again. There have never had one since the war commenced until one kees. Their names were W. T. Cape, W. A. Crabtree,

serter and hoped that I would never have one. I can't think of it for a moment. Most of the desertions lately ome would only write cheering letters to their friends in ne crime everything would go on so much better with us. up Sunday. Father was well. I saw Johnny and Robert on by the first opportunity two pairs socks as those I have to you about some time ago. I received Sadie's letter a Thompson. He has not yet

AR: MAIL CALL

n Colony of Indochina. A nationalist revolution led by the Vietnamese Communist Party drove out the
es intervened in Vietnam to maintain governments in southeastern Asia that would be sympathetic to the
erican soldiers were fighting in Vietnam. They used state-of-the-art helicopters, pilotless aircraft, chemical
gies. Despite the superior military technology, the war was long and difficult. American soldiers faced a

y to be televised daily. The American home front was already in the throes of social upheaval as the Civil
Moral antiwar groups formed, dividing opinion on the war effort. Mail played a vital role in communicating
the home front.

THE VIETNAM WAR: EX POST FACTO

GREEN EVERYWHERE

The war in Vietnam, a country dense with vegetation, was predominately a jungle war. In a brief experiment, mail for the troops was dropped from helicopters in green bags to hide it from the enemy. But the bags proved too difficult to locate in the green jungle. Some of the bags were lost, and the experiment was ended.

NEW FORMS OF MAIL

During the Vietnam War audiotapes were an alternative method for soldiers to communicate with people at home. During Operation Desert Storm in Iraq, the idea evolved into using videotapes to communicate. Today, soldiers can communicate through e-mail and other forms of satellite communication. With these electronic methods of communication, how will historians of the future document wartime?

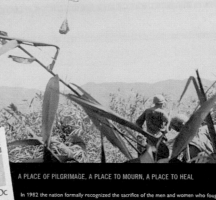

Vietnam Veterans Memorial USA 20c

A PLACE OF PILGRIMAGE, A PLACE TO MOURN, A PLACE TO HEAL

In 1982 the nation formally recognized the sacrifice of the men and women who fought in Vietnam with the dedication of the Vietnam Veterans Memorial in Washington, D.C. The memorial has become a place of reverence and contemplation, where people mourn their losses, try to understand their feelings, and pay tribute to those who lost their lives serving our country. The 140 black granite panels enshrine the names of the over 58,000 Americans who died in the war. This stamp, issued in 1984, commemorates the dedication of this memorial.

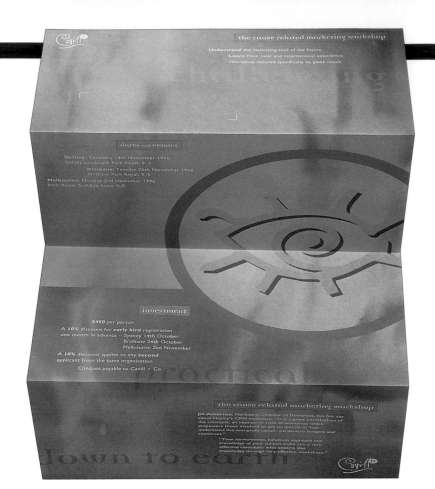

Cavill + Co. Brochure and Stationery

Art Director/Studio Andrea Rutherford/Smart Works Pty Ltd
Designer Andrea Rutherford
Client/Service Cavill + Co./ Marketing consultants
Paper Environment White Wove, Mulberry/Cypress Duplex Board, Prologue White
Colors Two PMS for letterhead; white and PMS for business cards; two PMS for brochure
Typefaces Gill Sans, hand-lettering for stationery; Gill Sans, Democratica, hand-lettering for brochure
Printing Offset, sheetfed
Cost 3,000 pieces of stationery and 1,000 business cards: design = $800; production/film = $515; printing = $1,650. 1000 brochures: design, production = $660; printing = $825.

Concept This client wanted the corporate identity of her new company to reflect the informal nature of her business style and her ability to devise "out-of-the-box" solutions for her clients. Hayley Cavill's unique character was the inspiration for the quirky gold, purple and green design of the stationery system. The same approach was taken for a marketing seminar announcement. An informal, user-friendly look was achieved through the unobtrusive treatment of the workshop's title ("down to earth"), but also through a three-fold format that measured 9" x 18" (22.9cm x 45.7cm) when opened.

Cost-Saving Techniques For the stationery system, two PMS colors were used and the art was positioned to maximize paper stock. The use of the duplex board introduced a third color to the design range. When the brochure was designed, space was allowed for an address label to be adhered for mailing in a windowed envelope. The registration form for the seminar was allocated to the back of the address panel so when it's removed, the registrant still has all the details concerning the seminar.

Special Visual Effect The eight-panel brochure was designed to be an attractive poster as well as an announcement.

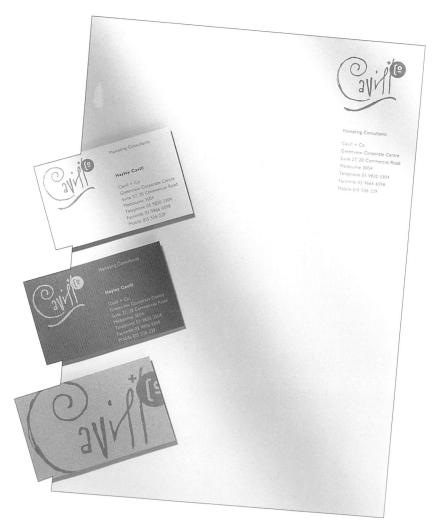

Somatix Therapy Corp.
1996 Annual Report

Art Director/Studio Bill Cahan/Cahan & Associates
Designer Sharrie Brooks
Illustrator Calef Brown
Client/Service Somatix Therapy Corp./Gene therapy
Paper Kashmir
Colors Four-color process, plus three PMS and a dull varnish
Typefaces Janson, Letter Gothic
Printing Offset lithography
Cost $1.60 per piece

Concept Use of illustrations that humanize the client's high-technology business is a clever and practical way to communicate with the investment community. The design of this annual report juxtaposes boldly colored, contemporary illustra-tions with electron micrographs and scientific charts. The result is a slick, balanced presentation that engages the investor and potential investor without short-changing the highly technical nature of the client's business or the financial information presented.

Cost-Saving Techniques The same paper stock was used for all text pages and only two illus-trations were necessary. The front-cover illustration was repeated on an inside page where it was re-colored in the color separation process.

Somatix
Therapy
Corporation

1996 Annual Report

A Leader in the Emerging Field
of Gene Therapy

Hematopoietic
Stem Cell
Gene Therapy

"At Somatix, it has long been our belief that multiple gene transfer systems will be required to successfully meet the scientific, clinical and economic challenges of making gene therapy a commercial success."

— David W. Carter
Chairman, President and
Chief Executive Officer

Somatix is focusing on the genetic modification of hematopoietic stem cells (HSCs) as a key strategy for the long-term therapy of chronic disease. HSCs are the precursor cell population from which the human body's entire complement of blood cells is continuously replenished. Genetically modified HSCs, therefore, are seen as an ideal cell type for long-term, sustained delivery of therapeutic proteins to the circulation (e.g., factors VIII and IX for the treatment of hemophilia).

In addition, there are other genetic diseases which result in a deficiency of proteins required for metabolic activities (e.g., Gaucher's disease, chronic granulomatous disease, etc.).

These diseases may also be candidates for gene therapy, and are likely to provide the initial validation of stem cell gene therapy procedures. Consequently, Somatix's stem cell gene transfer group is evaluating each of the Company's gene transfer vectors for use in the genetic modification of HSCs.

Our most advanced clinical effort in this area is gene therapy of chronic granulomatous disease (CGD), a life-threatening disorder in which mutation of the p47phox gene compromises the ability of white blood cells to eradicate bacterial and fungal infections. In collaboration with Harry Malech, M.D. at the National Institutes of Health (NIH), the Company is evaluating the use of gene therapy to treat this inherited genetic disease. Dr. Malech has completed a Phase I clinical trial in which patients received autologous hematopoietic stem cells, genetically modified to produce the p47phox protein. The study showed that p47phox-modified stem cells can be safely administered to humans and successfully generate functional white blood cells in CGD patients.

Somatix is focusing on the genetic modification of hematopoietic stem cells (HSCs). HSCs are the precursor cell population from which the human body's entire complement of blood cells is continuously replenished. All the different types of blood cells that derive from the HSCs will carry the same genetic modification. Each of these cell types can be used to fight different diseases.

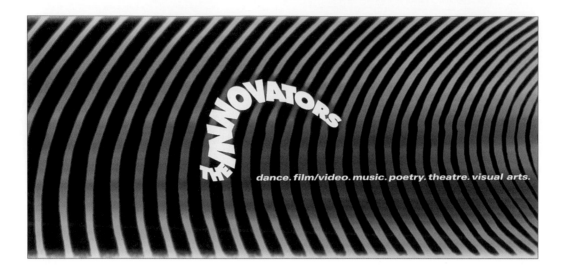

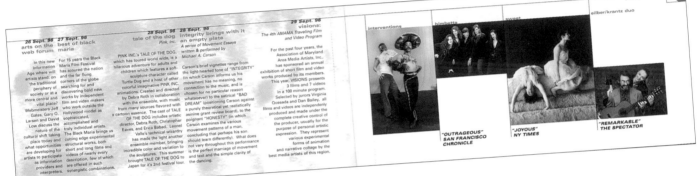

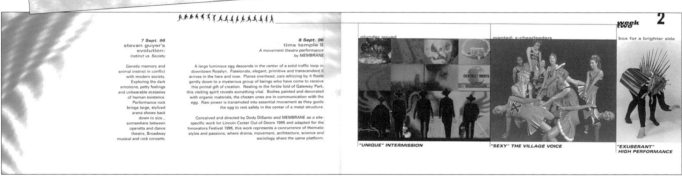

The Innovators: Program Guide

Art Director/Studio Hunter Wimmer/neo design
Designer Hunter Wimmer
Photographer Hunter Wimmer
Client/Service Gunston Arts Center Cultural Affairs Division of Arlington County/Arts institute
Paper 65# uncoated cover
Colors PMS Black and process cyan
Typefaces Univers, Swifty
Printing Offset
Cost $5,000 for 12,000 pieces

Concept The avant-garde nature of the performances featured in this art festival lent itself to an equally unconventional promotional brochure. This festival—entitled "The Innovators"—was sponsored by Arlington County, Virginia. The client originally came to the designers with a budget for a two-sided, two-color poster. The solution that neo supplied—within the same budget—was this hypnotic 8½" x 4" (21.6cm x 10.2cm), self-covered perforated booklet. The concept was based loosely on the format of a ticket booklet, with the events for each week of the festival presented on their own perforated page that could be removed without disturbing the remainder of the book. The inside of the front French-folded cover revealed a timeline of events for the five-week festival. A psychedelic, undulating graphic on the front cover successfully captures the essence of the pop-art genre and easily persuades the reader to move through the booklet and take in the photos and information on various performances.

Cost-Saving Techniques A self-mailer format alleviated the costs and hassles of envelope stuffing. The paper was supplied by the printer at a significantly reduced rate.

Special Production Technique The art used for the piece was taken from several sources, including a Victorian-era notebook filled with geometry homework, personal archive photography and various tags, buttons and cards. Other photography was donated by each artist.

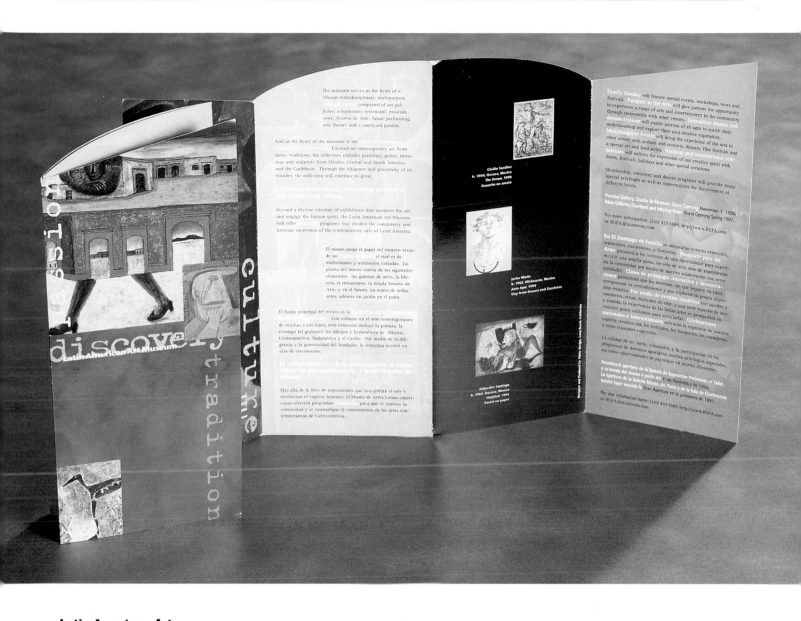

Latin American Art Museum Brochure

Art Directors/Studio John White, Jamie Graupner/White Design
Designers John White, Jamie Graupner
Illustrators Various Latin American artists
Client/Service Latin American Art Museum/Arts and cultural center
Paper Vintage Velvet
Colors Four-color process
Typefaces Rotis, Trixie
Printing Offset lithography
Cost Concept and design traded for pieces of art featured

Concept To announce the opening of the Latin American Art Museum in Long Beach, California, White Design devised this charismatic self-mailer showcasing the work of various Latin American artists. The three-fold brochure measures 17¾ inches (45.1cm) wide when opened. Through the use of a custom die cut, the brochure takes on the shape of an opened, arched doorway when it is unfolded. Various samples of Latin American art are displayed on two panels, while information in both English and Spanish about the museum, its exhibits and programs is stylishly placed on screened images of the art on the other two panels. The bright, bold colors of the artwork contrast nicely with the earthy tones the designers chose for the alternating panels of copy.

Cost-Saving Technique The piece doubles as a rack brochure and self-mailer. Designing it as a self-mailer helped cut down on further assembly costs.

Special Visual Effect The use of a custom die cut provides a dramatic and unusual presentation when the brochure is opened.

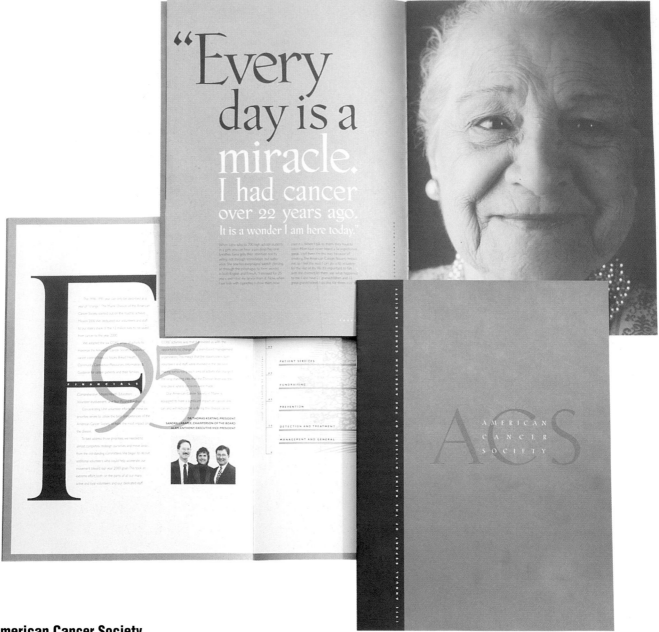

American Cancer Society 1995 Annual Report

Art Director/Studio Leslie Evans/Leslie Evans Design Associates
Designers Leslie Evans, Teresa Otul-Cummings
Illustrator Brian Wiggins
Photographer Warren Roos
Client/Service American Cancer Society, Maine Chapter/Non-profit association
Paper Simpson Coronado
Colors Three
Typefaces Felix, Gill Sans, Phaistos
Printing Offset

Concept The deceptively simple design of this annual report is instrumental in delivering a forceful and moving message on the ACS's financial status and organizational goals. To project a human feeling and evoke interest and emotion in what's normally a "strictly business" publication, the designers decided to focus on the ACS's vital core of volunteers who had been affected by the disease. Six volunteers were chosen to share their stories and personal feelings relating to why they volunteer. Each profile is thoughtfully presented on its own spread in the sixteen-page (plus cover) book. The design of each spread consists of a super close-up photo of the volunteer on one page with a quote and brief commentary on the other page. During the photo shoot, while doing the makeup, each volunteer was interviewed by the designer, and from this interview a quote was selected. The subjects were lit from one side, adding drama and interest to the black-and-white photos. A metallic ink was used throughout the piece to add richness and sophistication, while an uncoated bright white sheet was selected to soften the look and feel. To add dimension to the piece, a different metallic ink was used on the cover.

Cost-Saving Techniques Black-and-white photography was used, which cut down on separation costs. Most of the writing and editing was done by the designer, art director and production manager. The tree icon that's seen throughout the piece is the only piece of line art used. The designers applied various techniques to diversify and vary the look of the art. For example, it was ghosted on the front cover. A tone-on-tone approach was used on the inside front and back covers.

Pamela Barsky Wholesale Catalog 1.2

Art Director/Studio Mark LeRoy/Mark Designs
Designers Mark LeRoy, In-Sung Kim
Photographers SheShooter Photography, Carey Hendricks
Client/Service Pamela Barsky Wholesale/Specialty gifts
Paper Potlatch Mountie Matte, UV Ultra
Colors Two: black and PMS 732
Typefaces Dom Casual, Clarendon
Printing Offset
Cost Design = $800; photography = $800; printing = $1,700

Concept The client needed to show her journal/photo album products in the most cost-effective way possible. The challenge was met with this zany and playful catalog. A photo of a stack of spiralbound notebooks on the catalog cover piques the viewer's interest in just what type of products appear in the catalog. Once inside, the viewer is treated to a photo of each product with a simple but amusing line of descriptive copy. For example, "Raise a glass to this sophisti-cated journal," describes the wine journal. The ten-page brochure (including cover and flysheet) measures 3¾" x 10" (9.5cm x 25.4cm).

Cost-Saving Technique Product photos are printed as duotones. This was effective in cutting down on costs and was appro-priate because a majority of the products featured have natural-colored tones and reproduced nicely as duotones.

Special Visual Effect A grid effect was achieved by screen-ing back blocks of the PMS color on alternating products. This helped frame and organize the products and also helped create the illusion of more colors.

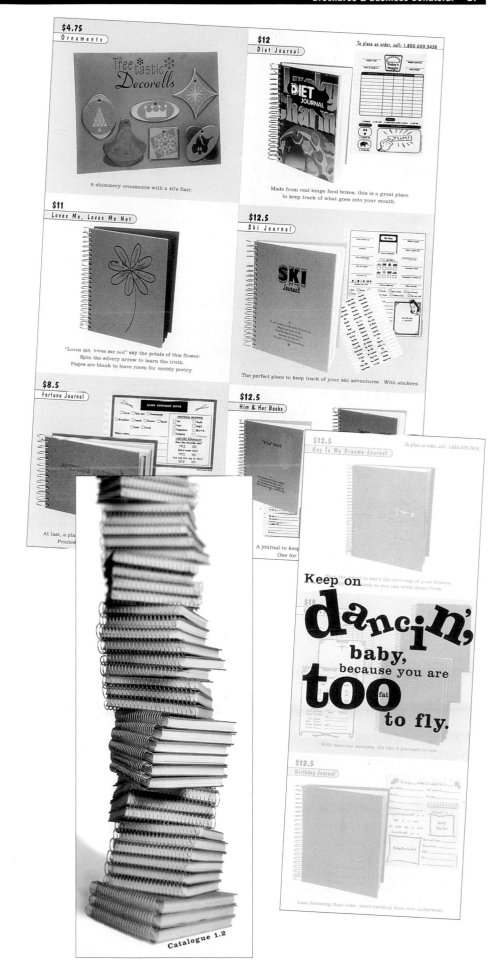

Wexner Center 1996-1997 Performing Arts Ticket Brochure

Art Director/Studio Terry Alan Rohrbach/Wexner Center for the Arts
Designers Terry Alan Rohrbach, M. Christopher Jones
Photographers Various
Client/Service Wexner Center for the Arts/Arts and culture institution
Paper Finch Opaque 80# Bright White Text
Colors Three spot colors
Typeface Helvetica Condensed

Printing Offset, sheetfed
Cost Budget was $14,000 and the total cost was $11,000 or $.56 per piece

Concept The energy and excitement of the performances scheduled during the Wexner Center's upcoming season are reflected in this twenty-page, 11" x 7½" (27.9cm x 19.1cm) brochure. The brochure is distributed primarily through direct mail and contains information on and schedules for all of the season's upcoming performances. The spiral image on the cover and the pictured performer create a strong sense of movement that's carried through the piece with lots of action photos and simple but effective type treatments. A color-coded tabbing system identifies the various categories of performances planned and a one-page ticket order form provides easy reference to the performance schedule.

Cost-Saving Technique Effectively pricing paper helped keep this project under budget.

Special Visual Effect Combinations of varying shades of original spot colors provided additional color effects and diverse treatment of photos.

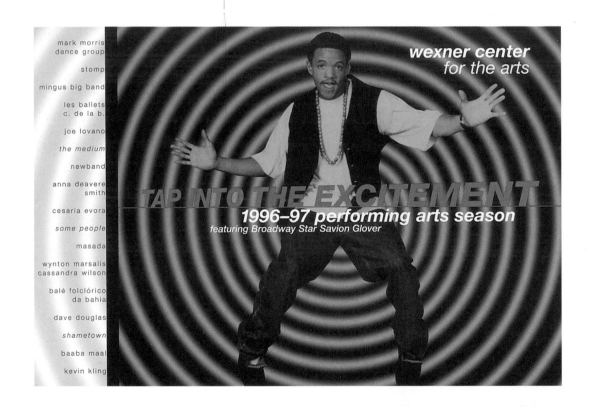

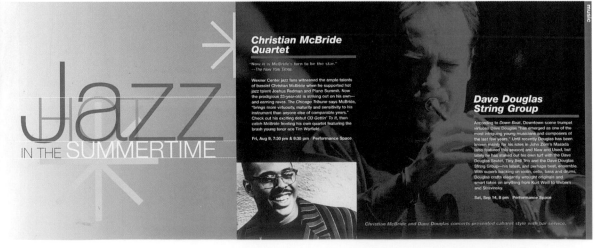

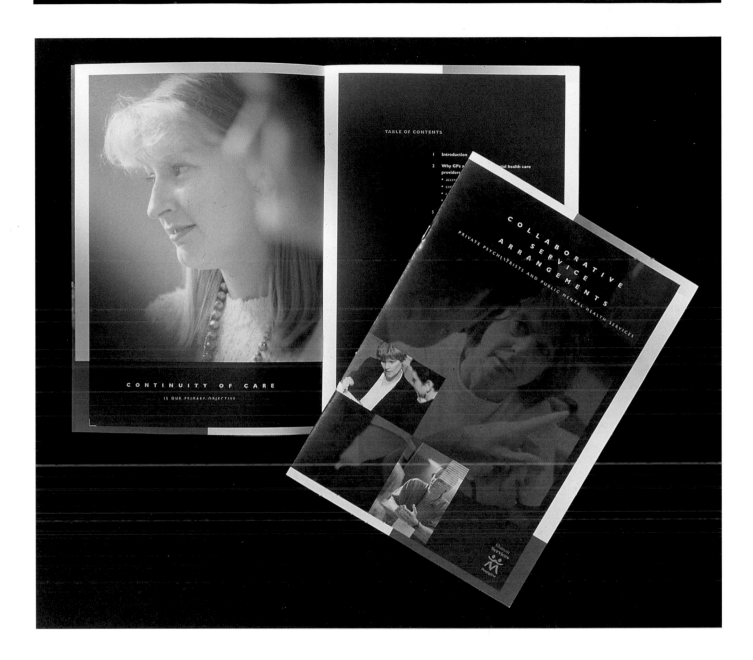

Sharing the Care Brochure

Art Director/Studio Jane Jeffrey/Smart Works Pty Ltd
Designer Jane Jeffrey
Photographer Mark Chew
Client/Service Department of Human Services in Melbourne/ Public mental health services and general health care
Paper Neenah Environment, Dur-O-Tone Butcher
Colors 3 PMS and black
Typefaces Gill Sans, Joanna
Printing Offset lithography
Cost Total cost for 12,500 copies of the mental health brochure and 3,500 of the collaborative service arrangements brochure, including photography, design, production and film = $20,125. Printing = $31,135.

Concept This project was designed to promote a program encouraging professional collaboration and coordination between general practitioners and mental health services for the benefit of the patients. To achieve the concept of open communication, the designers focused on the various professionals and the personal care they provide. Numerous photos that show interaction between care providers and patients strengthen the emphasis on the importance of communication. The brochure also features case studies on patients and the help they've received from care givers. Each case study appears on its own page with a stunning profile screened in the background. The result is dramatic and hard-hitting.

Cost-Saving Techniques
Although the budgets allowed for four-color process printing, the designers chose to use four spot colors and utilized the same images in both brochures. This was also more practical since it was difficult to find a sufficient number of workers willing to be photographed.

Special Visual Effect Duotones on a warm white uncoated stock helped convey the personal side of the services provided and created more emotion.

Informix Software, Inc.
1995 Annual Report

Art Director/Studio Bill
Cahan/Cahan & Associates
Designer Bob Dinetz
Illustrator Bob Dinetz
Photographer Daniel Arsenault
Copywriter Michael Pooley
Client/Service Informix
Software, Inc./Software
developer
Paper French Dur-O-Tone
Newsprint White 50# text
Colors Four-color process
Typefaces Dinnschriften
Mittelschrift, Caslon
Printing Offset lithography
Cost $1.20 per piece

Concept A collage of press clip-
pings on the client's business
and its industry in general pro-
vide punch and impact to this
annual report's cover and inter-
nal design. In fact, the piece
relies on enlarged reproductions
of pertinent press clippings to
explain the company's growth
and activity in its four key
areas. Each clipping is repro-
duced on a full page and is
printed on a newsprint stock to
give it that "fresh-off-the-press"
look. An assemblage of photos
representing the key areas com-
pletes each spread. To add more
impact, each page of photos is
printed in a different color—one
in an intense tone of red, anoth-
er green, another orange and the
fourth in blue.

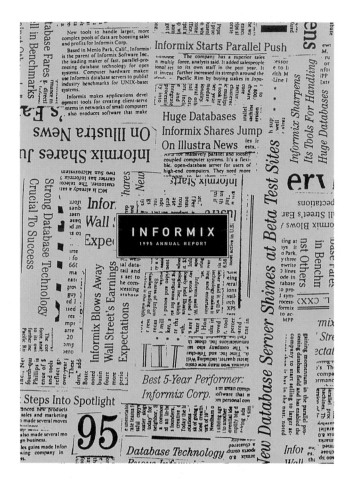

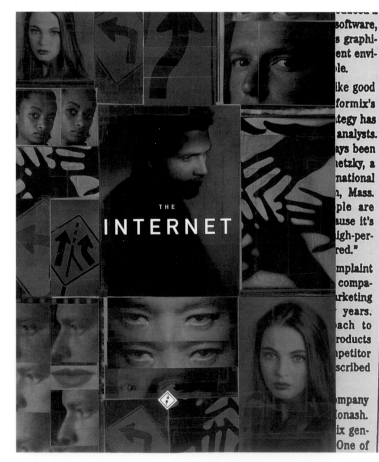

SFH&HA

South Florida Hospital & Healthcare Association

The Healthcare Consortium

The Year in Review

1996 Report to the Membership

1996

South Florida Hospital & Healthcare Association Annual Report

Art Director/Studio Charlie Calderin/Doink Inc.
Designer Charlie Calderin
Illustrator Charlie Calderin
Client/Service South Florida Hospital & Healthcare Association/Association for hospitals and health-care professionals
Paper Potlatch Vintage Velvet Creme
Colors PMS 5503, PMS 585 and black
Typefaces Thomas Paine, Joanna
Printing Offset
Cost Budget for the piece was $3,000. Actual costs were $1,590 for paper, printing and binding; $1,000 for design and $287.55 for prepress work.

Concept The designer of this piece was told to create something "classy" and "modern" and to have it ready to distribute to association members within two weeks. Undaunted by the fast-track schedule of the project, the designer cleverly combined colors commonly seen in a hospital setting and used simple rules and boxes to generate a contemporary, easy-to-read piece. The sixteen-page report is straightforward with topics clearly identified for easy reference. The intentional delineation of topics with lines and boxes evokes a sense of stability while the rough, typewritten appearance of the Joanna font add a human quality to the piece. Both are characteristics that members of the hospital association can identify with.
Cost-Saving Technique The number of colors was limited. Using tints provided more color variation and gave the appearance of more color in the report.
Special Visual Effect Varying type sizes created depth.

Consulting with the Palm Beach County Taxing District: The SFHHA worked with the Palm Beach Taxing District to determine the most effective utilization of the two rural hospitals located in the county. SFHHA President Linda Quick suggested at a meeting of the taxing district that the county would be better served by having both hospitals managed under one entity. The suggestion was later pursued by the hospitals.

South Florida the Topic of Numerous Studies: The healthcare market in South Florida was the focus of numerous studies conducted by the Robert Wood Johnson Foundation, the Physicians Payment Commission and The Advisory Board. The Association played a key role in all of the studies conducted in and about South Florida.

Affiliate Membership: With the expanded scope of the Association and the increased activity of The Healthcare Consortium, the Association doubled the number of affiliate members from the previous year during the first quarter. Affiliate membership went from 17 members in 1995 to 35 members in the first quarter of 1996.

SFHHA Members Challenge AHCA: Member hospitals with inpatient psychiatric services joined forces to fight retroactive recoupment of Medicaid monies based on faulty discharge screens being used by KePro.

The Second Quarter

SAFE HOSPITALS Campaign Launched: The work of the Safe Hospitals Task Force came to fruition during the second quarter. A patient information brochure entitled, "Questions to Ask Prior to Receiving Medical Treatment," was released to the media and member hospital patients on May 14th.

Legislative Briefings: The Association hosted two legislative briefings in June. The first was hosted by Wellington Regional Medical Center and featured Dr. James Howell, who graciously filled in for an ailing Senator William "Doc" Myers. The second was hosted by Mount Sinai Medical Center and featured Representative Elaine Bloom.

MEMBERS ONLY Receptions: In a move to increase networking opportunities among members of the Association, MEMBERS ONLY receptions were developed. The first such reception was hosted by the University of Miami Hospital & Clinics and saw well over 70 people attend.

Honored by Dade County Commission: The Association was awarded a Certificate of Appreciation for our efforts in assisting with the ValueJet site evacuation.

A More Focused Approach: In a move that will insure the future success of the Association, the Board's of both the Association and the Consortium moved to focus the efforts of the organization to better meet the needs of membership.

Affiliate Membership Grows: Starting the year with seventeen members, the Association grew by an additional 10 affiliate members by the end of the second quarter.

The Third Quarter

Fourth Annual Golf Tournament Planned: The South Florida Hospital Research & Education Foundation, the not-for-profit arm of the organization was pleased to announce that Codina Development and Gresham, Smith and Partners were title sponsors of this annual event scheduled to take place at Deering Bay Yacht & Country Club. Efforts were well underway to make this the most successful golf and tennis tournament ever presented to SFHHA members and their invited guests.

Early Hurricane Preparedness: This hurricane season started early with Hurricane Emily. The Association responded by collecting vital information from all area hospitals. This information was placed in a database and will be updated regularly.

Outsourcing Conference: SFHHA announced a joint education conference with the American Hospital Association on the subject of Outsourcing: Third Wave Healthcare Organizational Strategies. The conference took place in Naples, Florida and was most successful.

Legal Immigrant Healthcare: The association was at the forefront of advocacy on behalf of legal immigrants and the impact changes in Medicare and Medicaid would have on local hospitals, should those legal immigrants be denied healthcare coverage by the federal government.

Association Represented: The President of the Association served on a task force to advise Congressman Lincoln Diaz-Balart on the impact of federal welfare-reform legislation.

CEO Breakfast Well Attended: Executives from nearly 20 institutional and affiliate members attended a breakfast, were briefed on Association activities and had an opportunity to share news from their organizations.

MEMBERS ONLY Reception 2: The second MEMBERS ONLY reception was hosted by Florida Medical Center and again proved that networking is an opportunity to conduct meaningful business.

Committee Meetings: Several Association Committees were active the third quarter. Those holding meetings included: Government Relations, Membership, Bylaws and Finance & Management. Committees offer yet another avenue for members to be active in the organization.

Dade Members Fund Public Benefits: The Association successfully orchestrated an unprecedented private/public partnership between Dade member and non-member hospitals and the Public Health Trust's Jackson Memorial Hospital. The resulting pubic benefit fund will raise over $4 million.

Affiliate Membership: This membership category continues to grow. By the end of the third quarter, affiliate members grow to 50 members.

The Fourth Quarter

Miami Members Appear in FORBES: The Association coordinated design and production of a special advertorial in the September issue of FORBES with seven members.

3

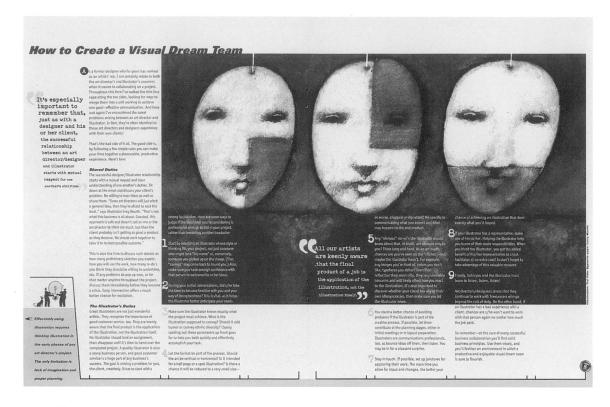

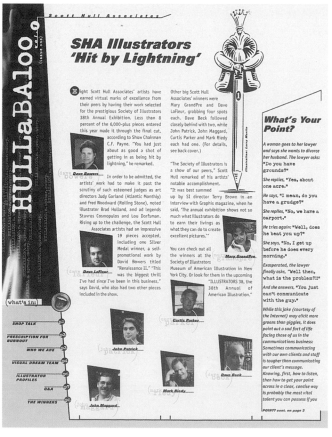

Hullabaloo Newsletter

Art Director/Studio Ken Botts/Visual Marketing Associates
Designer Tracy Meimers
Illustrators Larry Martin, Ted Pitts, David Beck, David Bowers, Franklin Hammond, John Ceballos, David LeFleur, Mark Riedy, John Maggard and others represented by Scott Hull Associates
Client/Service Scott Hull Associates/Creative illustration group
Paper Champion Benefit Chalk 70# text
Colors Two-color
Typefaces Various
Printing Offset; also published on Hull's web site
Budget/Cost $1,600 to print each issue. Hull eventually opted to discontinue printing the newsletter and published it on his company's web site.

Concept Look up the word "hullabaloo" in your *Webster's* and you'll find it's defined as an "uproar," or an "outcry." Leaf through the Hullabaloo newsletter published by Scott Hull Associates, and you'll find an equally energetic hubbub of information, illustration and commentary on the business of communicating. The two-color newsletter is distributed to buyers of illustration and art and those practitioners in the visual communications industry. Its purpose is not only to promote the work of the illustrators and artists who Hull represents, but also to facilitate awareness of trends and issues that affect the industry. Running eight pages in 8½" x 11" (21.6cm x 27.9cm) format, the newsletter is packed with engaging articles and snippets of information. Of course, the work of various illustrators is placed strategically throughout as an enhancement to the copy. Photos of the illustrators appear prominently on the front page of the piece, suggesting the importance of personal communication in building successful working relationships.
Cost-Saving Technique To eliminate printing and postage expenses, the newsletter was adapted so it could be published on the company's web site.

STATIONERY
& LOGOS

Furniture to Life Stationery

Art Director/Studio Chatchaval Khonkajee/Blind Co., Ltd.
Designer Jutarat Watanakul
Illustrator Jutarat Watanakul
Client/Service Furniture to Life Company Limited/Furniture designer
Paper Confetti, Starwhite
Colors Four-color process plus three PMS
Typefaces Snell, Democratica

Printing Offset
Cost $720 for 500 of each piece

Concept The functionality and personality of the furniture designed by the client is successfully communicated in the thoughtful, sophisticated design of this letterhead, envelope and business card ensemble. Three symbols—a chair, a hand with a pointing index finger and a leaf—subtly underscore the company's philosophy, which is to design furniture to live in. The symbols are skillfully positioned in side-by-side earth-toned blocks to form F2L. The earth tones coupled with the recycled speckled paper are indicative of life and environment. A combination of classic and modern type styles illustrates the range and character of the client's products.

Special Visual Effect The colored blocks on all three pieces are perforated as are the sides of the letterhead and business card. This adds texture and dimension that's easily associated with functional everyday objects.

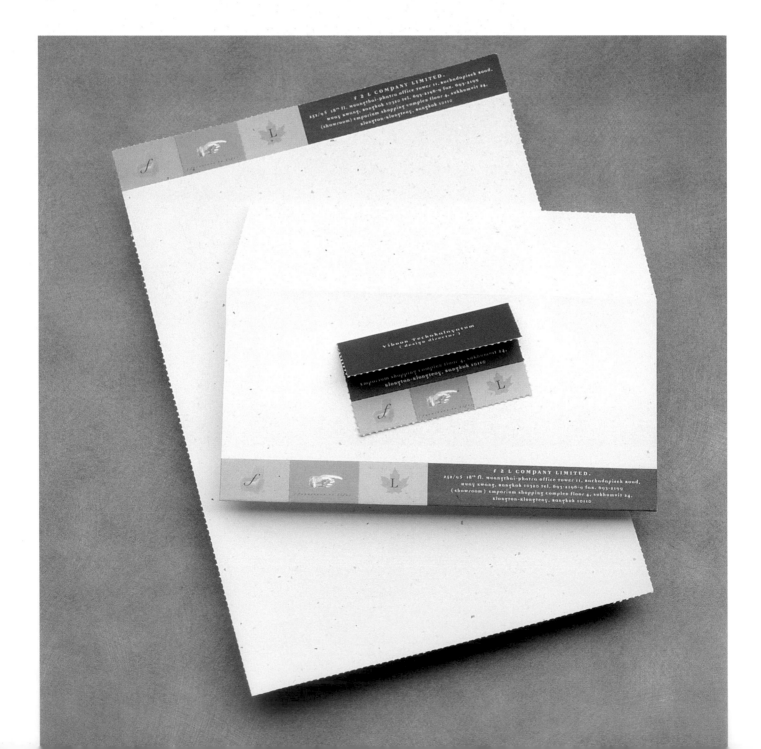

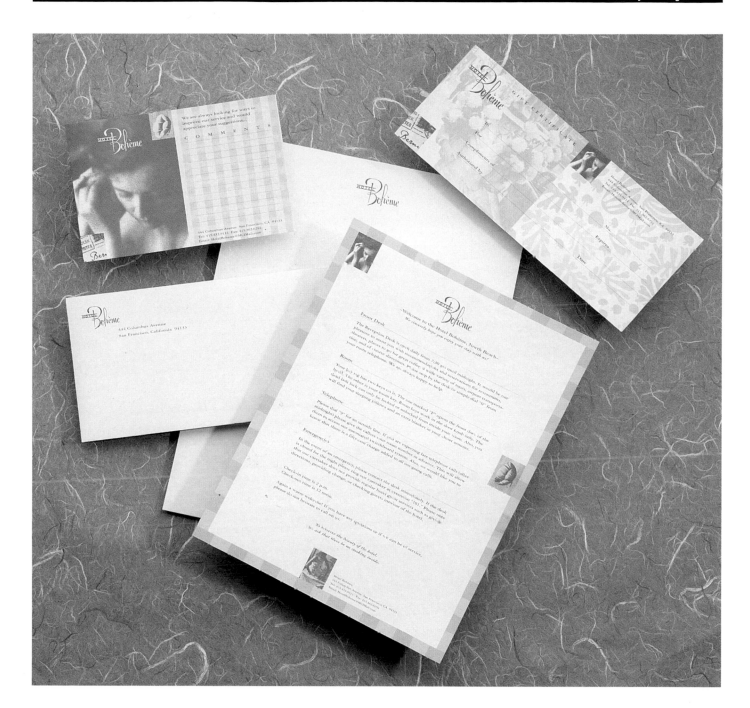

Hotel Bohème Stationery and Collateral

Art Director/Studio Tracy Moon/AERIAL
Designer Tracy Moon
Illustrator John Mattos
Client/Service Hotel Bohème/Hotel
Paper Graphika Parchment
Color Black
Typefaces Garamond, hand-drawn logotype for hotel name
Printing Offset lithography
Cost $.25 to $.65 per piece, including letterhead, envelopes, notepads, gift certificates and guest comment cards

Concept Walk into Hotel Bohème in San Francisco's North Beach area and you might think it's 1950-something and expect to see Jack Kerouac bantering about living the unrestrained life of a bohemian. In keeping with the highly creative but spartan tenor of the time period, the design of this packet is deliberately simple yet evocative. A hand-drawn logotype and the use of a black color on a gold-matted parchment paper stock give the pieces a comfortable, time-worn look. Black-and-white photos of ordinary 1950s scenes, such as a woman ironing a dress and an older gentleman carrying bunches of flowers, lend an easy, unhurried feel to the system.

Cost-Saving Technique One-color offset printing with no bleeds, solids or reverses on the basic letterhead, envelope, note paper and other everyday stationery materials helped reduce costs.

Special Visual Effect All of the imagery, including the striped and leaf patterns used on some of the pieces were derived from the actual hotel decor.

Oracle Corporation Stationery

Art Director/Studio Bill Cahan/Cahan & Associates
Designer Bob Dinetz
Illustrator Bob Dinetz
Photographers Various
Client/Service Oracle Corporation/Internet technology
Paper Hammermill Smooth 24#
Colors Match
Typefaces Caslon, Futura
Printing Offset lithography
Cost $.30 per unit

Concept Oracle is a leader in Internet technology and its applications and uses on networked systems. This stationery system was designed as a direct-mail promotion especially for attendees to a company-sponsored conference. It features a concept that's as fascinating and interactive as Internet technology itself. A series of questions concerning the future of Internet technology are printed backwards on the reverse side of the second, third and fourth sheets of the letter-head system. Each question is positioned on top of a provocative photograph that bleeds off the page. When you hold the sheet front side up, the question reads correctly from left to right and serves to pique the interest of the attendee. The handwritten appearance of the font used for the messages and the human element apparent in each photograph communicate the idea that Internet technology still has a human side.

Bob 'N Sheila's Edit World Identity System

Art Directors/Studio Dennis Crowe, Neal Zimmermann/ Zimmermann Crowe Design
Designers Dennis Crowe, Lucia Matioli
Illustrators Lucia Matioli and others
Client/Service Bob 'N Sheila's Edit World/Editorial services
Paper French Dur-O-Tone Newsprint White
Colors Two PMS
Typefaces Clarendon, Ribbon
Printing Offset
Cost Design and production costs were traded for client's editorial services. Printing: letterhead/second sheet = $.92; envelopes = $.18; business cards = $1.20; video sleeves = $.26; labels = $.25.

Concept The retro style of this identity system is a fitting design for the client company's name. The logo features four icons: drawings of Bob, Sheila, a blender and a globe. Different renditions of the icons then serve as design elements on the various pieces in the system. For example, the globe and other "worldly" images, including world maps and meteorological charts, provide a backdrop on the postcards, note cards and second sheet of the letterhead. The images of Bob and Sheila add a healthy dose of fun to the system. For example, a large watermark of a face—half of which is Bob's and the other half being Sheila's—dominates

the main letterhead sheet. Random placement of the blender—an appliance that's symbolic of modernism in the 1950s—on the various pieces adds an outlandish twist to the program.
Cost-Saving Technique Using standard manila envelopes printed with one color saved money and also complemented the system. The rest of the system is two colors.
Special Visual Effect The "squeeze" card animates the logo elements when squeezed.
Special Production Technique Screening the icons and "block-ing" the company name and address information creates the illusion of layers and depth.

Primal Screen Logo

Art Director/Studio Patrick Short/BlackBird Creative
Designer Patrick Short
Illustrator Patrick Short
Writer Doug Grimmett
Client/Service Primal Screen/ Broadcast and multimedia illustration and animation
Colors Black
Typeface Trixie
Budget/Cost Half of creative time was donated.

Concept: This intriguing logo speaks (or should we say "screams") volumes about the client's name and services. Primal Screen does illustration and animation for broadcast and multimedia. The designers chose a television/computer monitor screen as the central icon representing the mediums in which the client works. They then manipulated the shape so it resembled an open, screaming mouth—sort of a primal scream illustrated with reverberating lines. From there, they added a primitive-looking nose with spellbinding eyes reminiscent of indigenous Indian art. The end result is a fascinating logo that successfully tells the client's story.

Bella Donna Business Cards

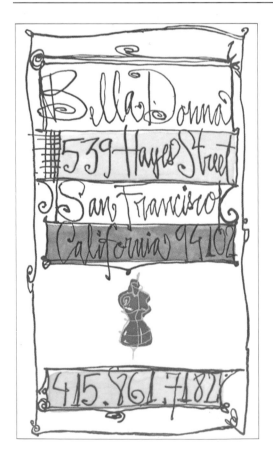

Art Director/Studio Marianne Mitten/Mitten Design
Designer Marianne Mitten
Illustrator Kelly Burke
Client/Service Bella Donna/ Clothing boutique
Paper Teton 80# cover warm white
Colors Three PMS
Typeface Hand-lettering
Printing Letterpress
Cost 3,000 business cards: design = $2,000; illustration/ calligraphy = $1,400; printing = $1,200; total cost = $1.53 per card.

Concept The upscale and contemporary personality of the Bella Donna women's clothing shop inspired the design of these business cards. The unique hand-lettering looks the same as you might see on a sign hanging outside an obscure but highly fashionable Paris boutique. Subtle olive green and purple colors and the illustration of a dress form convey the class, quality and personal attention shoppers can expect from the retailer.

Cost-Saving Technique The business cards doubled as hang tags.

Special Visual Effects Many of the fashions carried by the shop are made with beautiful textures and fabrics. Through letterpress printing, the designers were able to add texture and dimension to the piece.

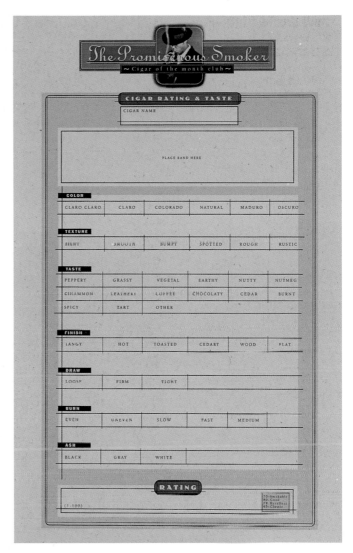

The Promiscuous Smoker Stationery

Art Director/Studio Steve Ditko/Knuckle Sandwich
Designer Steve Ditko
Photographer Bruce Racine
Model John Havel
Client/Service The Promiscuous Smoker/Cigar club
Paper Proterra, French Dur-O-Tone, Confetti
Colors Black
Typefaces Cornet, Helvetica
Printing Laser/photocopy
Cost The paper and photo were donated. The only real cost was for photocopying and materials, including 200 letterhead, 200 rating forms, 50 folders and 500 stickers.

Concept With a name like The Promiscuous Smoker to work

with, the designer of this piece had all kinds of fun possibilities for the design of stationery and collateral. He chose a cigar band shape as the central icon for the pieces. The band frames an enhanced photo of a James Bond-like character, which immediately suggests a certain degree of promiscuity. For the sticker on the outside of the folder, type was placed on top of the character to add obscurity and mystique.
Cost-Saving Technique The entire system was designed to be reproduced directly on a 600 dpi laser printer.
Special Visual Effect The smoke in the photo was added in Photoshop.

eandi design Stationery and Moving Announcement

Art Directors/Studio Erin Sarpa, Ilene Guy/eandi design
Designers Karen Mielke, Erin Sarpa, Ilene Guy
Client/Service eandi design/ Graphic design studio
Paper French Kraft 100# cover
Colors White and black
Typefaces Garamond, Helvetica Inserat
Printing Offset
Cost $3,700 for a quantity of 3,000

Concept When this design studio changed its name and moved its offices into a remodeled industrial building, the architecture, texture and materials of the new space were all the inspiration the designers needed to create this announcement and business collateral system. The announcement served multiple purposes: to provide clients with the new location information, invite them to an open house celebration and inform them of eandi's name change. It was cleverly developed as a series of cards bound together with a nut and bolt. For the business system, a simple but timeless logo punctuates the smooth, contemporary effect of white ink on the rich-looking French Kraft paper.
Cost-Saving Techniques The multiple cards for the announcement were designed with the same colors and set up to fit on a large press sheet so they could be printed with the business cards. For the business system, the use of a colored paper integrated a third color into the design.

Des Moines Plumbing Letterhead

Art Director/Studio John Sayles/Sayles Graphic Design
Designer John Sayles
Illustrator John Sayles
Client/Service Des Moines Plumbing/Plumbing parts and service
Paper Neenah Classic Crest grey 24# and 80#
Colors Two match
Typefaces Bell Gothic, hand-lettering
Printing Offset
Cost $.03 per piece

Concept The plumbing business hasn't changed much over the years. To communicate the idea that the client is still committed to good old-fashioned customer service, the designer of this stationery system chose a "retro" style that suggests friendly, high-quality service ideas associated with the 1940s and 1950s. Each piece in the system is marked with a different stylized graphic—a sink on the letterhead, bathtub on the envelopes, and faucet handle on the business cards. The images are printed in blue and yellow on a light gray stock, which together connote industrial, hard-working, blue-collar qualities. In addition to the stationery system, the designer created a leave-behind gift for the client's customers. White cotton rags with modified versions of the graphics screen-printed on them were tied up with a blue ribbon and left at the site of the service call along with the business card of the service technician. In addition to being practical and useful, the rags convey the client's commitment to an immaculate cleanup of the service site.

Cost-Saving Technique Using only two colors helped control costs.

Eakkasem Steel Co., Ltd.
Stationery and Logo

Art Director/Studio Chatchaval
Khonkajee/Blind Co., Ltd.
Designer Jutarat Watanakul
Client/Service Eakkasem Steel
Co., Ltd./Steel product
manufacturer
Paper Evergreen Aspen
Colors Three match
Typefaces Glasnost, Template
Gothic
Printing Offset
Cost $1,200

Concept In developing this logo
design, the objective was to cre-
ate something representative of
the client's business—the man-
ufacture of steel products for the
construction industry—and also
modern and contemporary in the
image it evokes. The result is
this letter "E" etched in a gray
metallic color that successfully
replicates construction steel.
The sharp, angular design of the
logo reinforces the idea that the
product is used to build and
construct. The angularity of the
logo is balanced by a more
rounded, contemporary design
for the stationery system.
Fashioned after tabbed file fold-
ers, the letterhead, envelopes
and business cards feature an
unusual shape. They are made
even more memorable and eye-
catching by their color scheme
of bright orange and black,
which connotes safety, caution
and strength in the industry.

Grant Telegraph Centre
Identity System

Art Director/Studio Sonia
Greteman/Greteman Group
Designers Sonia Greteman,
James Strange
Illustrator James Strange
Client/Service Grant Tele-
graph Centre/Condominium
development
Paper Astroparch, Kraft stickers
Colors Three PMS
Printing Lithography
Cost Development/printing =
$5,000 (approximately $.20 per
unit).

Concept This folder and sta-
tionery system serves as a major
marketing tool for Grant Tele-

graph, a luxury condominium
development located in
Wichita's historic Old Town.
Since the project was in the
early stage of development, the
correspondence material was
pertinent in establishing an
identity and image that helps
potential buyers envision the
final product. Target markets
are young professionals, empty
nesters and people interested in
a more urban, culturally rich
lifestyle. The correspondence
creates interest, energy and a

sense of history by drawing
upon the building's heritage as
an old telegraph office. The
folder, letterhead and stickers
employ graphic elements remi-
niscent of the art deco era. In
addition, the cover of the folder
features a description of the
condos in the format of a
telegraph.

Cost-Saving Techniques
Printing all collateral in one
color provided great savings.
Additional depth, surface vari-
ety, texture and color were

achieved by applying three-
color stickers.

Special Visual Effect The
uncoated and textured papers
contrast with the slick, coated
stickers and create a layered,
multidimensional feeling.

Special Production Technique
For the stickers, art deco icons
and elements were roughed up,
scanned, then placed in subtle
shades of tan. The folder's use
of black on black works effec-
tively in giving the stickers
extra pop.

Raymond Brothers Ltd.
Stationery and Logo

Art Director/Studio Andrew Lewis/Andrew Lewis Design
Designer Andrew Lewis
Illustrator Andrew Lewis
Production Rubin Lewis
Client/Service Raymond Brothers Ltd./Tents, awnings, industrial fabrics supplier
Paper Neenah Environment 25, Woodstock
Color PMS black
Typeface Copper Plate
Printing Offset lithography
Cost $.15 per piece for printing of envelopes, business cards and letterhead

Concept In creating a new identity for this ninety-five-year-old company, the designer chose to focus on its longevity, history and commitment to good, old-fashioned service ideals. A screened image of an old-fashioned storefront complete with striped awning is used as the background on letterhead and business cards. The warm neutral colors of the paper strengthen the concepts of tradition and trust while the use of one color evokes a sense of simplicity, characteristic of an era when things were simpler and more relaxed. The logo consists of side-by-side pictures of the Raymond brothers reproduced to look like portraits set in oval-shaped frames, again reinforcing the old-fashioned theme.
Cost-Saving Techniques One-color printing and the use of cheaper papers were simple solutions to the cost issue.

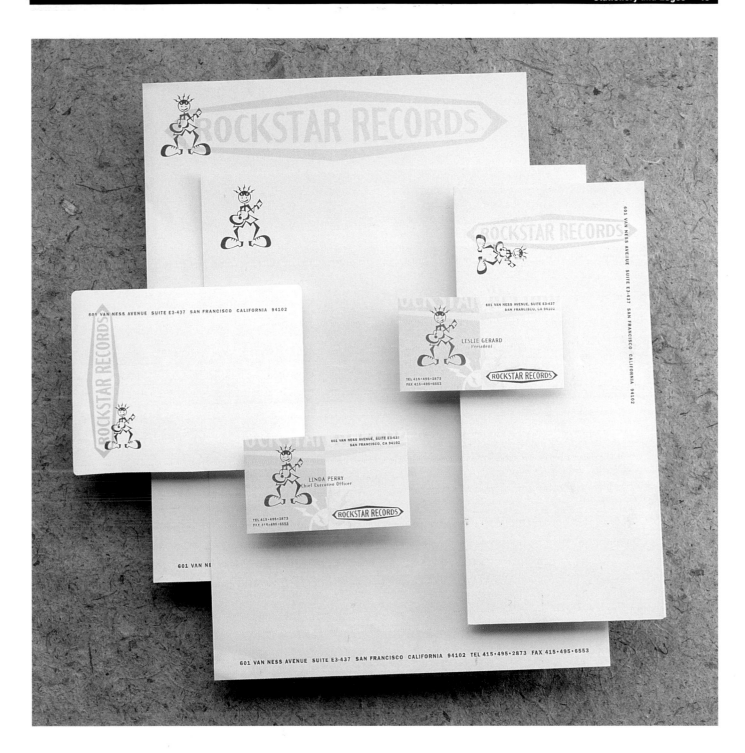

Rockstar Records
Corporate Identity

Art Director/Studio Mark
LeRoy/Mark Designs
Designer Mark LeRoy
Client/Service Rockstar
Records/Music label
Paper Neenah Classic Crest
Saw Grass
Colors Black and PMS 877
Typefaces Arbitrary, Franklin
Gothic

Printing Offset
Cost $.39 pcr piece

Concept At the request of the
company's owner—who is also
the former lead singer of the
rock band 4-Non-Blondes—the
design of this identity program
was adapted from a tattoo on
her arm. The program includes

letterhead, business cards,
envelopes and labels. The char-
acter, who is holding a guitar,
resembles a stick figure with
oversized feet and "electrified"
hair. The designer reproduced
the "charged" hair as an icon
that's screened back and repeat-
ed on the business card, adding
an element of energy and piz-

zazz. The logotype has a futur-
istic "Jetson-like" look that
enhances the energetic and
whimsical theme of the design.
Special Visual Effects The
designer played with scale, lay-
ers and screens to create a bold
and dynamic business card
(ideal for the "schmooze"
parties!).

Lenox Room Restaurant Stationery

Art Director/Studio Tracy Moon/AERIAL

Designer Tracy Moon

Photographer RJ Muna/RJ Muna Pictures

Client/Service Lenox Room/Restaurant

Paper Karma Natural White

Colors Two over one

Typefaces Viva 1500, Garamond 3 SC

Printing Offset lithography

Cost Letterhead, envelopes and business card series ranged from $.16 to $1.25 a piece. Because postcards and business cards were ganged, it reduced the price greatly.

Concept The sophisticated and elegant design of these pieces for an upscale restaurant in Manhattan disguise the client's request to minimize expenses. Unusual photographs of the restaurant's china, glassware and silver are skillfully manipu-lated to present various views of a fine dining experience. A soft mint green color is used prominently and connotes wealth and richness. As an aside, the designer came up with the line "Tip well and prosper" that was approved for use on all stationery materials. This line became a topic of conversation among restaurant patrons and introduced a jovial, light-hearted element to the stationery system.

Cost-Saving Technique Two-color duotones were used for all pieces.

Special Visual Effect Grain was added to soften images and add unusual effect.

Special Production Technique All imagery was specially altered (density of dot reduced) to reduce ink coverage. This eliminated the need for varnish, which would have meant the addition of a costly third color.

Lo Schiavo Design Group Stationery

Art Director/Studio Vicente Lo Schiavo/Lo Schiavo Design Group
Designers Dino Vettorello Filho, Gaston Lefebvre
Client/Service Lo Schiavo Design Group/Graphic design studio
Paper Kraft
Color Black

Typefaces Bank Gothic Lt., Stacatto 222
Printing Offset, ink jet
Cost $.58 per set (letterhead, envelopes, business cards)

Concept A simple graphic of a setting sun subtly communicates this design studio's desire to expand horizons with unique and innovative design solutions. The image sits atop a solid bar (representing the horizon) with the studio's name reversed out of it. Address and phone numbers in a modern typeface balance the presentation. For a more dramatic effect, the graphic was cut out in the business cards, further strengthening the idea that there are no bounds or limits to the creative solutions the studio can generate.
Cost-Saving Technique Some pieces in the one-color system can be printed in-house using an ink-jet printer and inexpensive paper.

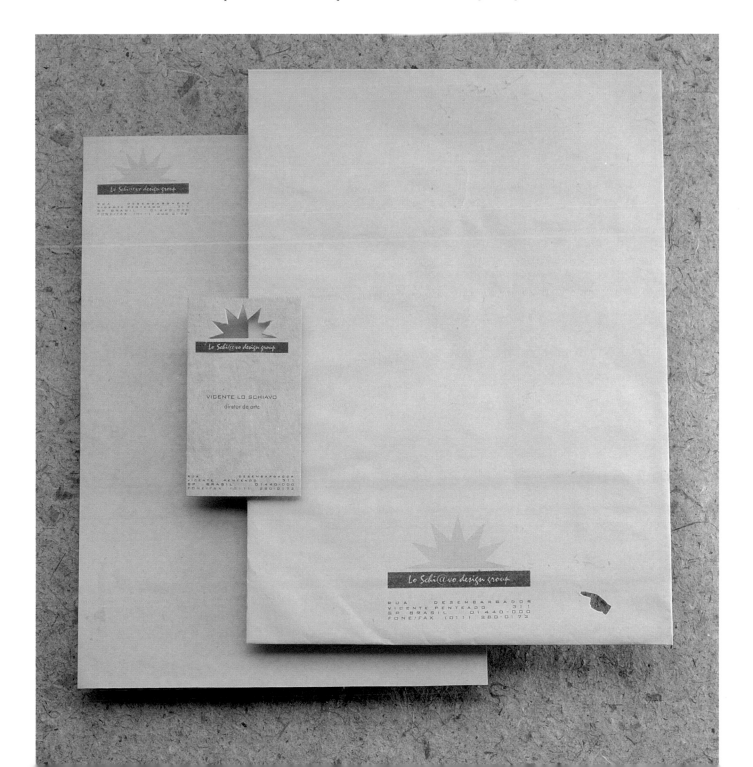

Font Reserve Launch Collateral

Art Director/Studio Brad Wilder/Glyphix Studio
Designers Brad Wilder, Brad Brizendine
Client/Service DiamondSoft, Inc./Software developer
Paper Neenah Environment Desert Storm
Colors Black, opaque white
Typefaces Officiana Sans, Minion
Printing Offset
Cost $1.50 per kit

Concept To maintain product identity across all media while keeping cost to a minimum, the designers of this identity program for a font management software application developed a "modular messaging" system. Frames or modules serve as information containers for icons, short marketing messages and font specimens with information on the type and foundry. The modules form an extensive grid system that succinctly identifies the company, its products and their features. It also helps communicate the idea of stability and strength. To tie the product in with the company's other marketing materials and its web site, the textured paper used for the identity program became the base on which everything else was built, including the background of the software application itself. In addition, the grid structure was repeated in the company's trade show booth, which included stacked wooden cubes affixed with the same messages seen in the modules in the identity materials.

Cost-Saving Technique By using black and opaque white inks on a darker, textured paper, the designers were able to achieve a higher perceived value in the materials. This also made it easier to generate press releases and other documents that had the same consistent look.

Special Production Technique Doing a single-hit white (opaque white) on dyed paper gives a point of focus yet retains a rich subtlety very difficult to achieve even with more expensive printing techniques.

Zack Smith
Identity System

Art Director/Studio Neal Zimmermann/Zimmermann Crowe Design
Designer John Pappas
Client/Service Zack Smith/Musician and composer
Paper French Dur-O-Tone
Colors Two PMS
Typeface Rockwell
Printing Offset
Cost Business cards/letterhead = $350.

Concept The theme for this identity system was developed from images and quotes found in an obscure 1950-something technical guide on sound and music. The designer happened upon the book while perusing in a San Francisco bookstore and thought the straightforward and occasionally dopey information it contained matched the slightly irreverent approach he wanted to take in creating the identity program. It also proved to be an approach the client—a musician/composer with a rock-and-roll background—appreciated. The circular logo consists of the images of musical notes and lightning bolts that cleverly form the client's company initials of Z.S.M. Photo negatives of images in the technical guide were reproduced in large dot screen formats and used on the business cards, labels and stationery. In addition, quotes from the book on sound and music, such as "A vibration causes sound waves in the air," were added here and there to different pieces to continue the quirky theme.

Cost-Saving Technique The studio found a low-cost printer who traded printing costs for design work.

Visual Kraf Co., Ltd.
Stationery

Art Director/Studio Chatchaval Khonkajee/Blind Co., Ltd.
Designer Chatchaval Khonkajee
Illustrator Saharut Sirichai
Client/Service Visual Kraf Co., Ltd./Multimedia production
Paper Reflex
Colors Three PMS
Typefaces Template, Gothic
Printing Offset
Cost $2,100 for 2,000 of each piece

Concept The designer of this stationery system tells the client company's story through a crafty combination of elements that represent art and technology. As a provider of multimedia production services, the company relies on both artistic flair and computer technology to meet the multimedia needs of its customers. Icons representing both disciplines are used to illustrate the company's expertise in marrying art and technology. A keyboard and artist's palette appear on the letterhead, an easel and computer monitor are on the envelopes, and paintbrushes and a mouse show the relationship on the business card. In addition, different fonts for the two words in the company name portray the successful marriage between the traditional and the contemporary.

CARDS, ANNOUNCEMENTS & INVITATIONS

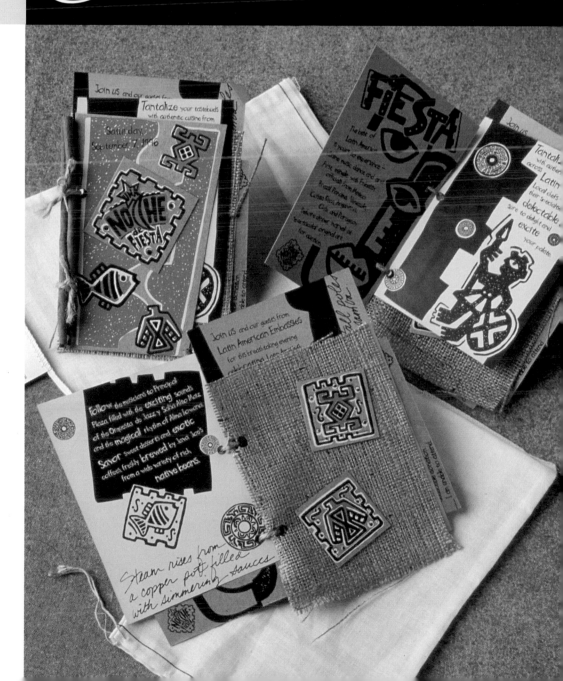

Wexner Center "Extraordinary" Exhibition Invitation

Art Director/Studio Terry Alan Rohrbach/Wexner Center for the Arts
Designer Terry Alan Rohrbach
Writer Jennifer Boyd
Editor Ann Bremner
Client/Service Wexner Center for the Arts/Arts and cultural organization
Paper Cougar Cover Opaque 65#
Colors Two spot
Typefaces Blur, Typewriter
Printing Sheetfed, offset
Cost Printing = $1,190; paper = $450; total = $.26 per piece.

Concept Promoting out-of-the-ordinary art and photography in an ordinary manner was the concept behind this piece. The booklet is an invitation to the Wexner Center's opening-night exhibitions, both of which feature the masterful transformation of ordinary objects and events into something extraordinary through artistry and photography. The six-page, 4½" x 6¼" (11.4cm x 15.9cm) booklet follows a simple handbook format. An ordinary typewriter-like font creates impact that allows photos of some of the work featured to take center stage.

Cost-Saving Technique High-resolution scans of the images were picked up from a catalog accompanying the exhibition. This enabled all art to be supplied directly to the printer on disk.

Special Visual Effect Overprinting a black screen on the second color produced additional color effects.

MEMBERS OPENING
Wexner Center for the Arts

Explore the entertaining and intriguing world of Peter Fischli and David Weiss. These Swiss artists work as a team to inventively transform ordinary objects, images, and materials into witty and thought-provoking photographs, sculptures, installations, films, and videos.

Fischli and Weiss: In a Restless World

PETER FISCHLI AND DAVID WEISS: IN A RESTLESS WORLD was organized by the Walker Art Center, Minneapolis. Support for the exhibition was provided by PRO HELVETICA Arts Council of Switzerland, the National Endowment for the Arts, Lannan Foundation, and Samsung Electronics America, Inc.

The exhibition is presented at the Wexner Center with the support of the Lannan Foundation, Los Angeles, and the Wexner Center Foundation.

Peter Fischli and David Weiss, *Outlaws*, 1984

Arizona Human Rights Fund Invitation

Studio After Hours Creative
Design After Hours Creative
Photographer Tim Lanterman
Client/Service Arizona Human Rights Fund/Nonpartisan human rights organization
Paper Potlatch Vintage Velvet Creme 80# cover
Colors Black and one PMS
Typefaces Democratica, Engravers Gothic BT
Printing Offset
Cost $3,000 for 4,000 invitation sets

Concept This piece for the Arizona Human Rights Fund serves a dual purpose: as an invitation to a dinner honoring people who have been active in the fight for basic human rights, and as a strong message about the importance of equality. The design team developed the theme, "A place at the table," and united it with two of the most potent symbols of equality in America— the U.S. flag and the Pledge of Allegiance. Using a square 5¾-inch (14.6cm) booklet format, the oath begins on the cover with a photo of the flag positioned on a classic background design. As the reader follows the pledge through the piece, they see a progression of photos of the flag presumably being folded up and put away. When they get to the last page, the flag appears folded into a dinner napkin and placed at a table setting, thus communicating the idea of a place at the table for all people. The simple design is greatly enhanced by the dramatic photography, interesting type treatment and warm, rich colors.
Cost-Saving Techniques The design incorporates only two colors. The photography was donated, as was the design and creative time. Plus, paper from a canceled print job was used.

Gallery of Southern Photographers Announcement

Art Director/Studio Tom Varisco/Tom Varisco Designs
Designers Tom Varisco, Jan Bertman
Photographer Jack Spencer
Gallery Director Vickie Basseti
Client/Service Gallery of Southern Photographers/Gallery
Paper Quintessence Dull
Colors Black and one PMS
Typefaces Gill Sans, hand-lettering
Printing Offset
Cost Total = $250 for 500; $.50 each.

> At this point the fish was pretty ripe and he wasn't too crazy about holding onto it. Some people have called it an offering. I don't know. It's up to each viewer really to come up with a meaning.

Jack Spencer, "Man with Fish," Como, Mississippi, 1995, Brown Tone Gelatin Print, 14"x14"

Concept Jack Spencer is well known for his personal and often mystical photographs of life in the South. To generate an invitation for a showing of Spencer's work, the designer went to the source to provide inspiration. He chose Spencer's photo "Man with Fish," and interviewed Spencer on how the photo came about and his thoughts concerning it. He reproduced his notes as hand-written text on the front of the invitation. The result is a brief but thought-provoking commentary on the photographer and his art.

Cost-Saving Technique The cards were printed six up, six cards at a time. No prepress work was necessary.

Birthday Announcement

Art Director/Studio Sondra H. Phillips/Images Graphic Design
Designer Sondra H. Phillips
Illustrator Sondra H. Phillips
Client Sondra H. Phillips
Paper French Sparkletone
Color Black
Typeface Goudy
Printing Laser
Cost The only costs were an antique check machine and a label maker and tape. Total = $26.

Concept Old paper samples, an antique check machine and a little ingenuity were all combined to create this one-of-a-kind birthday greeting. Swatches of a brown and sand-colored paper stock are layered on the front of a card. The number "29" is punched out of the top layer with a machine used by banks in the nineteenth century to imprint amounts on checks. A piece of black tape with the word *again* on it pokes fun at getting older, while giving the piece a tactile, interactive appeal. Inside, more layered swatches of paper with the message "Make Another Wish," complete the presentation.

Cost-Saving Techniques The card was created using the paper samples left over from a previous job. All printing was done on the laser printer.

Special Production Technique Each card was produced individually by hand.

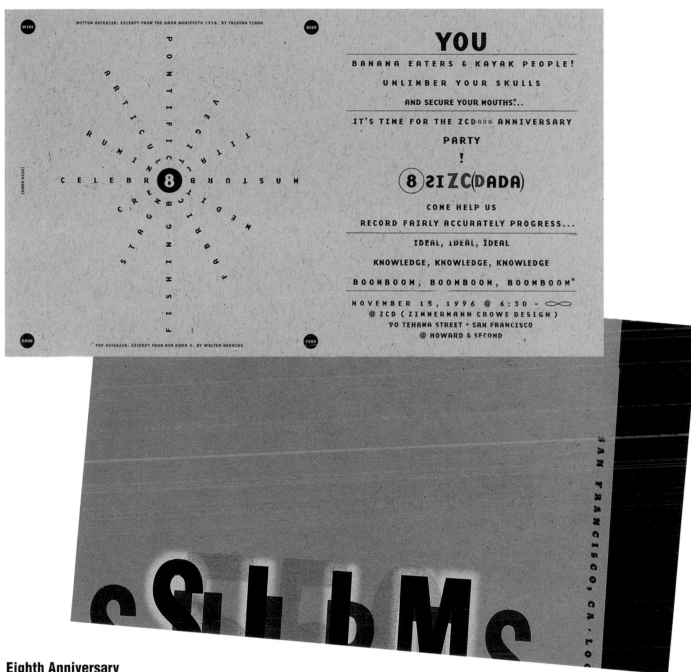

Eighth Anniversary Party Invitation

Art Director/Studio Neal Zimmermann/Zimmermann Crowe Design
Designer Neal Zimmermann
Illustrator Neal Zimmermann
Client/Service Zimmermann Crowe Design/Design studio
Paper French Rayon
Colors Black, red
Typeface Base 9
Printing Offset lithography
Cost Film = $36; printing = $75; total for 300 = $111.

Concept This party invitation to celebrate the design studio's eighth year in business borrows heavily from the ideals and beliefs of the 1920s Dada art movement. The movement was characterized by bizarre, nihilistic reactions to art. The invitation revisits the period primarily through equally bizarre yet thought-provoking copy. A graphic of a circular numeral 8 with words that end in the sound of eight positioned around it like spokes on a bicycle wheel is prominent on one side of the 8" x 4⅝" (20.3cm x 11.8cm) card. It quickly involves the recipient and establishes the studio as bold and saucy. Quotes from Tristan Tzara and Walter Mehring, outspoken supporters of the movement, are incorporated into the arbitrary, unshackled style of design.

Cost-Saving Techniques The cards were printed on paper left over from other jobs. Make-ready from another studio job was used. Ink coverage was limited.

Una Noche de Fiesta Invitation

Art Director/Studio John Sayles/Sayles Graphic Design
Designer Jennifer Elliott
Illustrator Jennifer Elliott
Copywriter Kristin Lennert
Client/Service Iowa Council for International Understanding/ Cultural institute
Paper Chipboard, Hopper Hots
Colors Four match
Typefaces Scotty normal, hand-rendered
Printing Offset and screen printing

Concept This most unusual and eye-catching invitation set a festive mood for an event celebrating the sights, sounds, smells and tastes of Latin America. The invitation consists of four pieces of chipboard, each cut at different angles, and a piece of burlap that are hole-punched and bound with heavy brown twine. A cinnamon stick is also bound with the chipboard and burlap. The invitation was delivered in a muslin drawstring bag. The presentation as a whole is highly interactive and tactile. In addition, bold graphics representative of Latin American culture and different brightly colored fluorescent papers convey energy and activity, and compel the recipient to get involved.

Cost-Saving Techniques
Different Hopper Hots fluorescent papers added color without additional cost. Industrial chipboard was a cost-efficient paper choice. The assembly and hand work was provided by volunteers.

Special Production Techniques
Individual pieces of chipboard were drilled so they could be bound with twine and a cinnamon stick. The chipboard covers were trimmed by hand on a cutting board for a deliberate lack of precision that added to the invitation's unrestrained, uninhibited appeal.

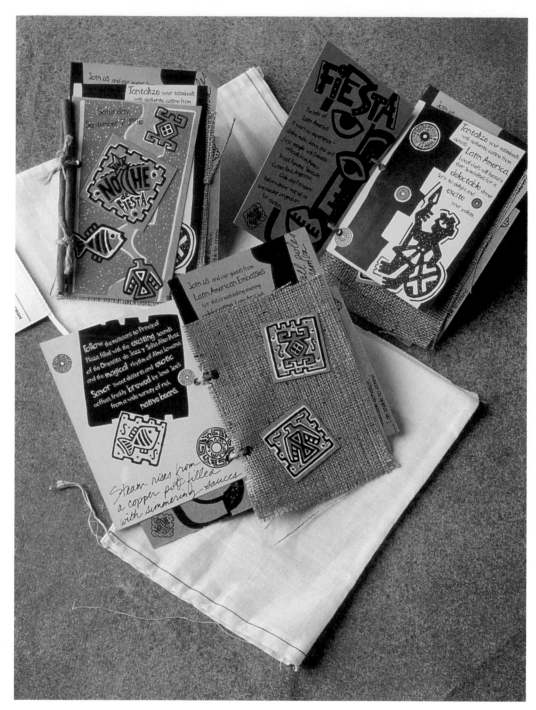

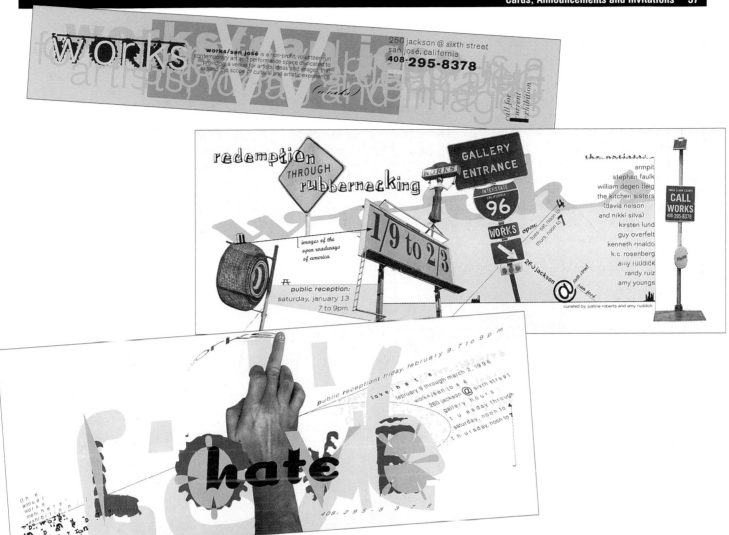

Works/San Jose Invitation

Studio Joc Miller's Company
Designer Joe Miller
Photographer Joe Miller
Client/Service Works/San
Jose/Nonprofit art and perfor-
mance organization
Paper Cards: 140# Index; book-
marks: Astroparch, Opaque
Colors Black for cards; one
PMS for bookmarks
Typefaces Helvetica, Univers,
others
Printing Offset
Cost The design was donated.
High-resolution linotype film =
$20; printing of 1,500 cards =
$135.

Concept The Works/San Jose is
a nonprofit, volunteer-run con-
temporary art and performance
space designed to provide a

venue for artists to show their
work. This series of cards
announcing various upcoming
exhibitions and showings com-
municates the cutting-edge,
sometimes wacky but always
thought-provoking nature of the
work and ideas on display. The
designer's goal, in addition to
conveying the tone and subject
of the exhibits, was to position
the organization as one that

challenges the cultural and artis-
tic ideas and ideologies of con-
temporary artists and, subse-
quently, their publics. This is
achieved through a combination
of images, icons and text that
are skillfully assembled to force
the recipient to study and ana-
lyze the information presented.
Cost-Saving Techniques The
designer did everything includ-
ing hand-modeling for the Love/

Hate exhibition card. Book-
marks were printed on the trim
of the sheet of an unrelated job.
Special Visual Effect The
designer used Photoshop to cre-
ate new lettering on road signs
and billboards for the "redemp-
tion through rubbernecking"
card.

Mann-Townsend Wedding Invitation

Art Director/Studio Leo Raymundo/FORM
Designer Leo Raymundo
Clients Jennifer Mann and Haig Townsend
Paper Arches Cover
Colors Black and PMS 365u
Typefaces Centaur, Garamond
Printing Letterpress
Cost Paper = $50; hand-set type = $100; prepress setup = $240; printing of 200 invitations = $240; total = $630; $3.15 per invitation.

Concept This wedding invitation, which combines old-world type specimens, scientific botanical illustrations and traditional letterpress printing methods, is a tribute to the clients' aesthetic sensibilities (both are archi-tects). The textured ivory paper and understated illustrations off-set the very basic yet practical invitation copy. Together, the various pieces of the invitation make a modern, asymmetrical yet classical design statement.

Cost-Saving Techniques The designer reproduced illustrations found in old botanical textbooks. Plus, the design ser-vices were donated.

Special Production Technique Traditional hand-set type composition illustrates the uniqueness of letterpress printing.

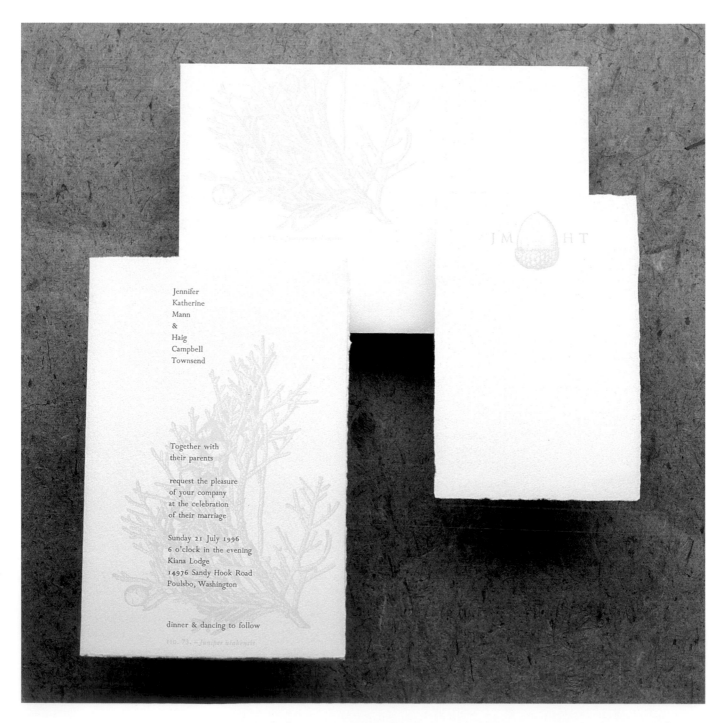

Jennifer
Katherine
Mann
&
Haig
Campbell
Townsend

Together with
their parents

request the pleasure
of your company
at the celebration
of their marriage

Sunday 21 July 1996
6 o'clock in the evening
Kiana Lodge
14976 Sandy Hook Road
Poulsbo, Washington

dinner & dancing to follow

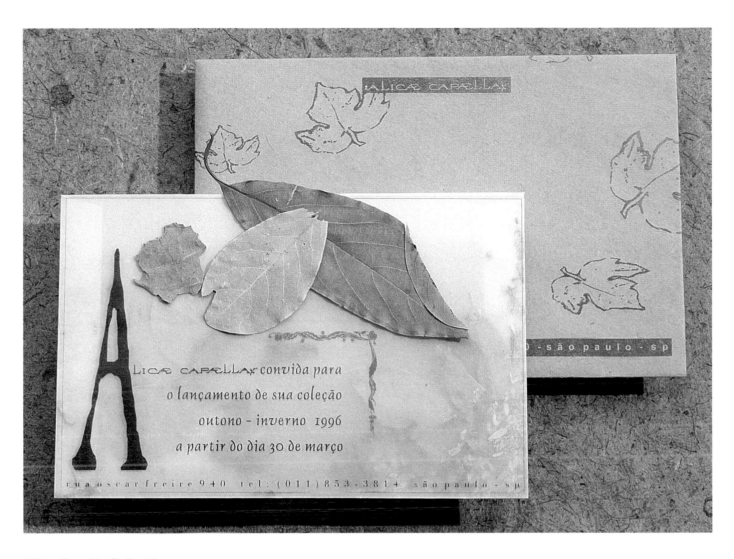

Alice Capella Collection Invitation

Art Director/Studio Vicente Lo Schiavo/Lo Schiavo Design Group
Designers Dino Vettorello Filho, Gaston Lefebvre
Client/Service Alice Capella/Artist
Paper Kraft, clear
Colors One for envelope; two for inside envelope
Printing Offset
Cost $.25 per piece

Concept The client for this piece requested that it look natural and express the aura and aromas of autumn. The low-cost solution is a thoughtful and pleasurable delight to the senses. A clear envelope, with brief information on the artist's work printed on its front, is stuffed with potpourri. Through the envelope, the earthy colors of the potpourri reflect the brilliant orange and gold hues of autumn's changing leaves. When you open the envelope, you're treated to the aromatic and natural scent of wood and foliage. The clear envelope is then placed in a kraft paper envelope decorated with soft green leaves that look as if they're falling from a tree. The brown envelope further strengthens the natural, woodsy feel of the piece.
Cost-Saving Technique Paper used for the envelopes was inexpensive.
Special Visual Effect Potpourri inside the clear envelope looks very much like leaves that have fallen from trees in the autumn.

National Film Registry Opening Night Invitation

Studio Wexner Center for the Arts
Designer Terry Alan Rohrbach
Client/Service Wexner Center for the Arts/Arts and culture institution
Paper Simpson Evergreen 80# cover; 24# White Wove
Colors Three spot colors for invitation; two spot colors for envelope; one for poster
Typeface Helvetica Condensed
Printing Sheetfed for invitation and envelope; Blackline Diazo for poster
Cost Poster = $.10; invitation/envelope = $.30; total = $530.

Concept What more engaging way to promote America's film history and heritage than with a head shot of Oliver Hardy and the accompanying tagline "Another fine evening!" This invitation for an exhibition of big-screen films from the Library of Congress' National Film Registry Tour uses the renowned comic character as an icon to pull the individual pieces of the promotion together. In addition, recognizable scenes from other notable films were drawn upon to create dynamic visual imagery on the 11" x 17" (27.9cm x 43.2cm) black-and-white poster that was mailed with the invitation.

Cost-Saving Techniques The very low cost of Diazo printing used for the poster enabled the designers to devote most of the budget to the invitation and envelope. Offset printing was done on a two-color press. All images were scanned on an in-house flatbed and the entire project was supplied to the printer on disk.

Special Visual Effect White ink produced a translucent effect on the invitation card and created the illusion of more color.

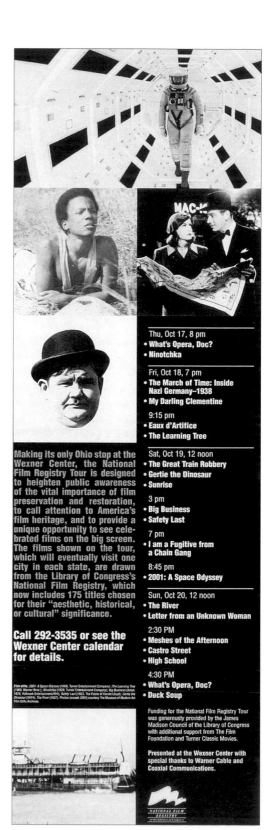

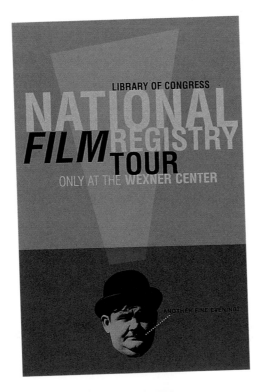

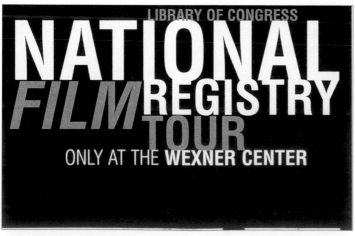

Images Graphic Design
Postcards

Art Director/Studio Sondra H. Phillips/Images Graphic Design
Designer Sondra H. Phillips
Paper Crushed Leaf Cream
Printing Color photocopy
Cost $.54 per card

Concept Images Graphic Design believes that postcards are the perfect vehicle for communicating with clients—from business cards to advertisements to personal correspondence.

Plus, the cost to mail them is considerably lower than the standard thirty-two-cent letter. For this correspondence, the designer collaged old tickets from the Hollywood Park race course, and sheets of music to create a friendly, warm greeting. The ensemble provokes a certain romance and nostalgia that leaves a comfortable feeling with the recipient.

Cost-Saving Techniques The principle cost-saving technique is that postcards cost less than letters to mail. The cards are color-photocopied, thus saving costs on four-color printing.
Special Production Technique The postcards are produced on a color Xerox that accepts card stock, which provides the look and feel of real postcards.

Computerworld 1996 Holiday Card

Art Director/Studio David Salanitro/Oh Boy, A Design Company
Designer David Salanitro
Illustrator David Salanitro
Client/Service Computerworld/Magazine
Paper Simpson Starwhite Vicksburg
Colors Two plus match colors
Typefaces Minion, Melmo
Printing Offset
Cost Professional fees = $2,160; expenses = $1,809; $2.95 per piece.

Concept The only thing the client requested of the designer for this holiday greeting card was to incorporate a dove into the design. Although there was no budget for photography, the designer was able to generate this understated yet poignant image of a dove entirely in Photoshop. A sheet of flypaper with a simple holiday greeting was placed on top of the card to soften even further the dove image and subtly communicate the message of peace.
Cost-Saving Technique Only one side of the sheet was printed.

Wishing you a wonderful Holiday Season
and a New Year filled with Health, Happiness and Peace.

"Peace" from Computerworld *12/96*

In celebration of the holidays and in the spirit of giving, Computerworld, Inc. will make a donation in your name to one of the following organizations of your choice.

☐ San Francisco AIDS Foundation

☐ Big Brothers/Big Sisters

☐ Meals on Wheels

☐ Harvest Food Bank

Your Name *Company*

Please make your selection and return this postage paid postcard. If your response is not received by December 12, we will make a selection for you. Best wishes for a Happy, Healthy Holiday.

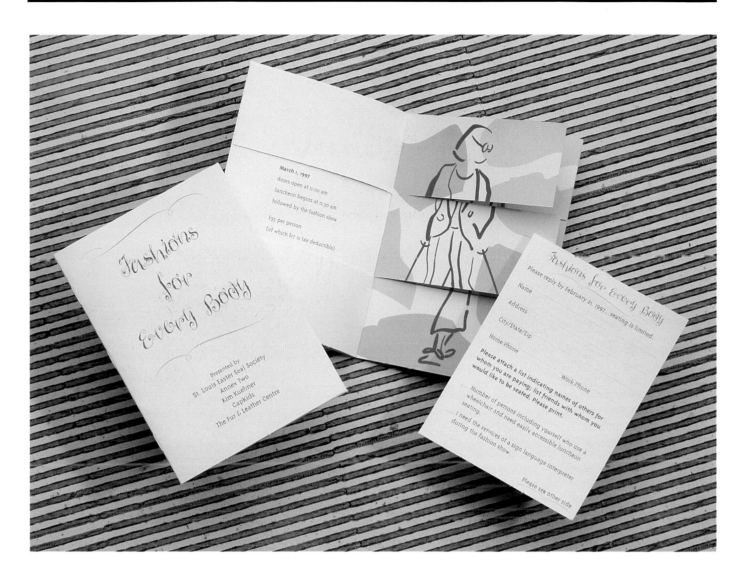

Fashions for Every Body Invitation

Art Director/Studio Amy Knopf/ Kiku Obata & Company
Designer Amy Knopf
Illustrator Teresa Norton-Young
Client/Service St. Louis Easter Seal Society/Charitable foundation
Paper Mohawk Vellum
Colors Two PMS
Typefaces Triplex, Housemaid
Printing Offset
Cost $.60 per piece, which included the invitation, reply card, reply envelope and mailing envelope; total = $1,200.

Concept This playful, interactive invitation was designed to follow the theme of the event, "Fashions for Every Body." Each of the four inside pages in the booklet features a fashion illustration. Horizontal cuts on the pages at the midriff and knee areas of the illustrated models enable the viewer to "mix and match" the various fashions, thus, conveying the idea of "fashions for every body." The contemporary illustrations combined with a more old-fashioned typeface enhance the event's appeal to a wide-ranging audience.

Cost-Saving Techniques The invitation was printed in two colors with a self cover. The inside pages were printed on one side only and cut by hand. The paper was donated.

Special Production Technique The entire invitation, including the illustrations, was created on the computer and supplied to the printer on disk.

Delaware Humanities Forum Invitation

Art Director/Studio Paul DiCampli/Janet Hughes and Associates
Designer Paul DiCampli
Artist Jack Lewis
Photographer David Petersen
Account Executive Janet Hughes
Client/Service Delaware Humanities Forum/State program for the arts and humanities
Paper Starwhite Vicksburg
Colors Four-color process
Typefaces Poplar, Engravers Roman
Printing Sheetfed
Cost $.97 per unit

Concept The designer's goal for this piece was to communicate how artist Jack Lewis's painting has influenced the town of Bridgeville, Delaware, where he has lived for the last sixty years. The invitation is for the premier of a video on Lewis's life, being held in Bridgeville. An understated reproduction of a photograph of the artist is the key element in the design. The photo, which was taken some fifty years ago, is of Lewis painting on the side of a Bridgeville street. It was skillfully merged with a portion of one of Lewis's

murals that appears on the side of a building ("If you lived here you would be home now"). The result is a realistic representation of the artist's style and personality.

Special Visual Effect The designer merged the fifty-year-old photograph of the artist on a street painting with one of his murals that is on a side of a building.

MELISSA McGILL

51 GREENE STREET NEW YORK NEW YORK 10013 212. 941 9888 FAX 212. 343 7903 MARCH 21 - APRIL 27 PROJECT ROOM

BOESKY & CALLERY

Boesky & Callery Exhibition Announcements

Art Director/Studio D. Mark Kingsley/Greenberg Kingsley, Inc.
Designer D. Mark Kingsley
Illustrators Burt Barr, D. Mark Kingsley
Photographer Lisa Yuskavage
Client/Service Boesky & Callery Fine Arts/Art gallery
Paper UV Ultra Vellum; 88# Strathmore Bright White
Colors Two color on two of the cards; one color on the third card
Typeface Bell
Printing Offset
Cost Approximately $.40 each.

Concept A 9" x 4" (23.5cm x 10.2cm) format and a simple stretch of type across the front of each card provide continuity among these announcement cards for showings of the work of various artists. The artist's name and information about the showing are positioned across the center of each card. A carefully prepared background design differentiates each card and conveys the artist's individuality and style. Other variations are achieved through the use of color and paper.
Cost-Saving Technique The modular format helps reduce design costs.
Special Production Technique To reduce banding in the background vignette, the designer used a coarse screen and ran the paper through the press to print on the shorter dimension's direction.

LISA YUSKAVAGE

BOESKY & CALLERY FINE ARTS 51 GREENE STREET NEW YORK NEW YORK 10013 212. 941 9888 FAX 212. 343 7903 OCTOBER 10 - NOVEMBER 16
OPENING RECEPTION THURSDAY OCTOBER 10

BURT BARR

SIGRID HACKENBERG

BOESKY & CALLERY FINE ARTS 51 GREENE STREET NEW YORK NEW YORK 10013 212. 941 9888 FAX 212. 343 7903 JANUARY 10 - FEBRUARY 8

CONNIE WALSH

OPENING RECEPTION FRIDAY JANUARY 10 6-8

PBS Holiday Card

Studio Grafik Communications, Ltd.
Designers Michelle Mar, Judy Kirpich
Illustrator Richard Hamilton/PBS
Client/Service Public Broadcasting Service/Publicly funded broadcasting service
Paper 80# Finch opaque cover, 70# Finch opaque text
Colors Black and one PMS

Typefaces Ablefont, Gill Sans
Printing Offset

Concept The fun, engaging format of this eight-page, 7-inch (17.8cm) square holiday greeting card for PBS is consistent with the educational nature of the service's programming. The booklet features PBS's popular P-Pals characters. Fashioned as a coloring book, complete with a pack of four crayons, the greeting promotes interactivity between the viewers and PBS programming. At the same time, it spotlights each P-Pal, which was an idea suggested by the client. A cherry red cover with type reversed out conveys the bright merriment typical of the season.

SELF-PROMOTION

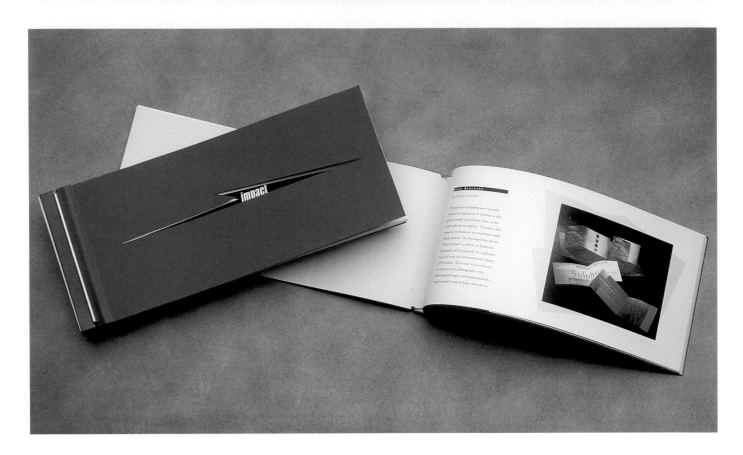

neo design Portfolio Book

Art Director/Studio Hillary Radbill/neo design
Designers Hillary Radbill, Harold Riddle, Randy Gusemann
Photographers Len Rizzi Studio, Robert Rathe Photography
Copywriter David Rosenberg
Paper Warren Lustro Gloss, Potlatch Vintage Gloss 80# text, GlamaClear Natural 100# text, Fox River Confetti 65# cover
Colors Four-color process plus matte varnish
Typefaces Berkley, Compacta, Futura Family, Cochin
Printing Offset
Cost Out-of-pocket expenses for materials and printing totaled $3,000 for 2,000 sets.

Concept Originally conceived as a promotional miniportfolio for prospective and current clients, this book has been the most successful promotional piece to date for neo design. The binding is flexible so that pages may be inserted and removed, which allows the book to evolve as new work is added. An unusual 12" x 5" (30.5cm x 12.7cm) format and a simple but classy design successfully illustrate the studio's work and capabilities. The vivid red cover is marked by a die-cut shape that communicates movement and direction. It also reveals the word "impact" on the first inside page. Each subsequent page in the booklet features a neo project accompanied by an explanation of the special challenges of the project and how neo met them.

Cost-Saving Techniques All printing was ganged to alleviate excess printing costs. Cover pages were hand cut and logo pages were generated in-house. The size was designed around the trim space of another print run, and the flexibility of the binding allows the printing of additional pages when the opportunity for ganging arises. The twelve four-color pages within the book were produced over the course of fourteen months and over the span of many print runs.

Special Visual Effect The hand-cut arrow reveals the book's title: Impact.

Valentine's Day Greeting Card

Art Director/Studio Toni Schowalter/Toni Schowalter Design
Designer Toni Schowalter
Paper Finch Natural, Neenah Classic Columns Cover
Colors Two PMS plus black
Printing Offset
Cost Printing was about $500 for 550 pieces; and paper for the cover was an additional $200.

Concept Toni Schowalter Design used this interactive Valentine's Day greeting card as an appropriate opportunity to express "heartfelt" thanks to its clients for their business and support. The card is in a 4¼" x 5½" (10.8cm x 14.0cm) booklet format. A bright red cover stock is embellished with a single metallic red heart sticker. The eight inside pages feature illustrations of heart-related puns and expressions that the recipient is challenged to complete. For example, an illustration of a heart with a fork in it represents the saying "eat your heart out." The same heart shape used on the cover is repeated inside in a bright red PMS and in varying sizes on each page. Answers to the quiz along with the studio's Valentine's Day greeting appear on the last page of the booklet.

Cost-Saving Techniques The inside pages were printed in two colors on one 11" x 17" (27.9cm x 43.2cm) sheet and the studio used archived illustrations. Staff members applied the metallic heart stickers to the cover. A mediocre printer was used, with no bleeds or heavy coverage.

Special Visual Effects Using varying sizes of the same heart shape on the inside pages keeps the design together. Also, the style of the archived illustrations used is consistent and provides continuity.

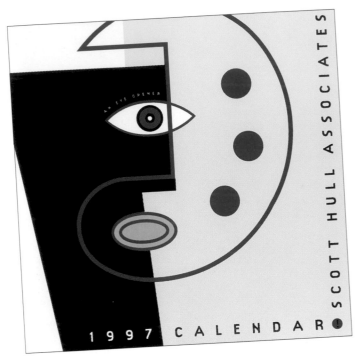

Scott Hull Associates Calendar

Designer/Studio Steve Gabor/ Salvato, Coe & Gabor
Illustrators David LaFleur, Kari Alberg, Franklin Hammond, Larry Martin, Josef Gast, Geoff Smith, Ted Pitts, Greg Dearth, Helen D'Souza, David Bowers, Andy Powell, Curtis Parker
Paper S.D. Warren Lustro Dull Recycled
Colors Four-color process, plus several PMS colors and a matte and gloss varnish
Typefaces Citizen, Offisinia
Printing Offset
Cost $.55 each, including postage

Concept What better way to keep your name in front of clients and potential clients year-round than with a calendar that features your work and your name on every page? This 11" x 11" (27.9cm x 27.9cm) calendar features full-color reproductions of illustrations done by the artists whom Hull represents. Even when the year is over, the eye-opening illustrations are suitable for framing. The practicality and staying power of this piece are enhanced even more by the neat, classic design of the actual calendar pages. A dynamic back-cover design pictures each artist featured in the calendar.

Cost-Saving Techniques Hull and the designer were able to work out an arrangement with the printer in which Hull's calendar and one for the designer's studio were printed free of charge in exchange for a calendar design for the printer. The designer generated a different cover for each calendar but used the same format for the calendar pages.

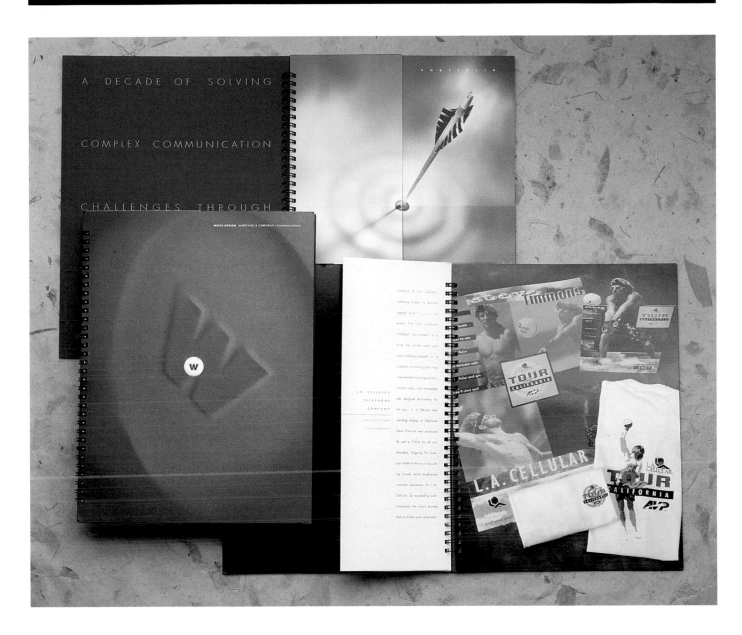

White Design
Capabilities Brochure

Art Directors/Studio John White, Jamie Graupner/ White Design Marketing & Communication
Designer Jamie Graupner
Illustrator Clayton Preuitt
Photographer Hacob Khodaverdian
Paper Starwhite Vicksburg, Vintage Velvet
Colors Four-color process, plus two PMS
Typeface Futura
Printing Offset lithography
Cost $5.30 each

Concept While the designers of this elaborate capabilities brochure claim they could have bought a Mercedes with the money spent to produce it, they were able to utilize a number of cost-saving measures without sacrificing impact or quality. A bold black cover featuring a dramatic metallic halftone of the company's logo is pierced by a dime-size embossed foil-stamped logo. Inside, provocative "atmospheric" photography and half-sheet pages form a sin-

gle photographic image that makes an undeniably strong statement about the firm's commitment to providing "targeted, results-driven marketing solutions." Various projects are highlighted, each on its own full page, through sharp photos that contrast handsomely with the black and slate backgrounds. A half-sheet with copy describing the project precedes each full page.

Cost-Saving Techniques The cover printing used one color

only and the foil embossing. Use of half-sheets helped control costs, as did binding the pages in-house.

Special Visual Effects Three different color treatments were applied to a single photographic image on the opening spread. The image was then cut into vertical and horizontal half-pages. Printing the image on uncoated paper gave it a softer look.

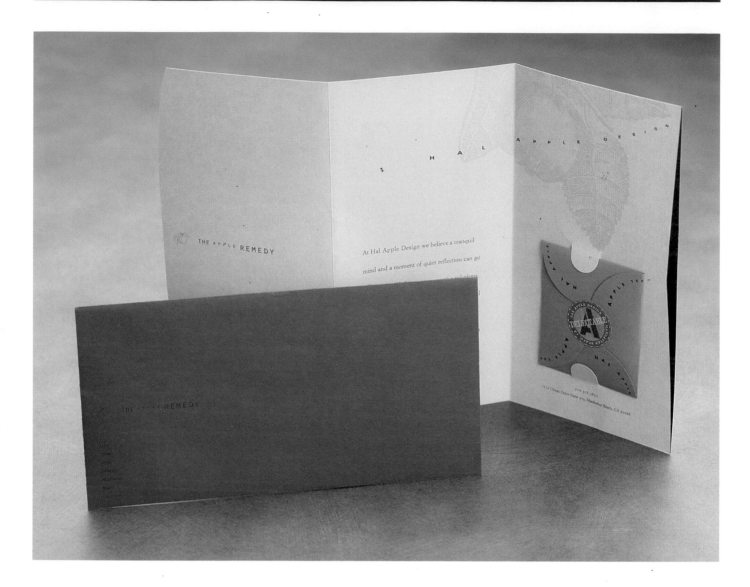

Apple Tea Promotion

Art Directors/Studio Hal Apple, Alan Otto/Hal Apple Design & Communications, Inc.
Designers Alan Otto, Jason Hashmi
Paper Strathmore Renewall Moss, Protera Flecks Sea Moss, Fox River Confetti Red and Yellow
Colors One PMS for folder, two PMS for label
Typefaces Garamond, Univers
Printing Offset
Cost $1.50 per unit, which consisted of envelope, letter, sticker and tea bag in a special tea folder.

Concept The name of this design studio lends itself to all kinds of apple-related promotions and themes. This piece is a

pleasant, palatable variation on the apple concept. The piece consists of a letter that subtly prompts recipients to ponder and reflect on a communications program designed by Hal Apple while sipping on the sample of tea included. Each sample is housed in its own specially designed envelope that bears the studio name. It is sealed with a red and green sticker that also features the studio name, plus a "DELECTABLE" stamp across the middle. An image of an apple suspended among leaves from a branch accentuates the letterhead and is repeated on the bright red envelope the letter was mailed in. Entitled "The Apple Remedy," the promotion appeals to the senses and

encourages recipients to interact. It also creates a strong association between the studio and an American icon that has many positive connotations.
Cost-Saving Techniques One-color printing on recycled paper stock helped control costs. The studio also used the stickers and envelopes for other promotion pieces.
Special Visual Effects The letter stock is cut so that its short sides are rounded. It is then accordion-folded with the copy printed across the length.
Special Production Technique Old engraving clip art was scanned to generate the image on the letter and envelope.

THE
Holidays

A time to look
beyond the *surface*
at what is
really important

SEASONS GREETINGS FROM
Get Smart Design Company

A Card for the Holidays

Art Director/Studio Jeff
MacFarlane/Get Smart
Designers Tom Culbertson,
Kevin Mellen
Printing & Film Union-
Hoermann Press
Paper 17# Gilclear
Colors One PMS on each side
Typefaces Stone Serif, Frutiger
Printing Offset
Cost The only real expense was
printing, which totaled $196,
including envelopes

Concept Unusual type treat-
ments and unconventional holi-
day colors ironically help
enforce the traditional holiday
sentiment this greeting card
bespeaks. The congested
arrangement of reversed-out
type on the cover and inside the
card create the illusion of falling
snowflakes. A simple message,
"The Holidays—A time to look
beyond the surface at what is
really important," encourages
the recipient to study the artistry
of the design as well as the feel
and texture of the paper.

Cost-Saving Techniques The
studio was able to control costs
by printing only one color on
each side of the card, by using a
paper stock the printer had on
hand, and by sizing the card to
fit in a standard-size envelope.

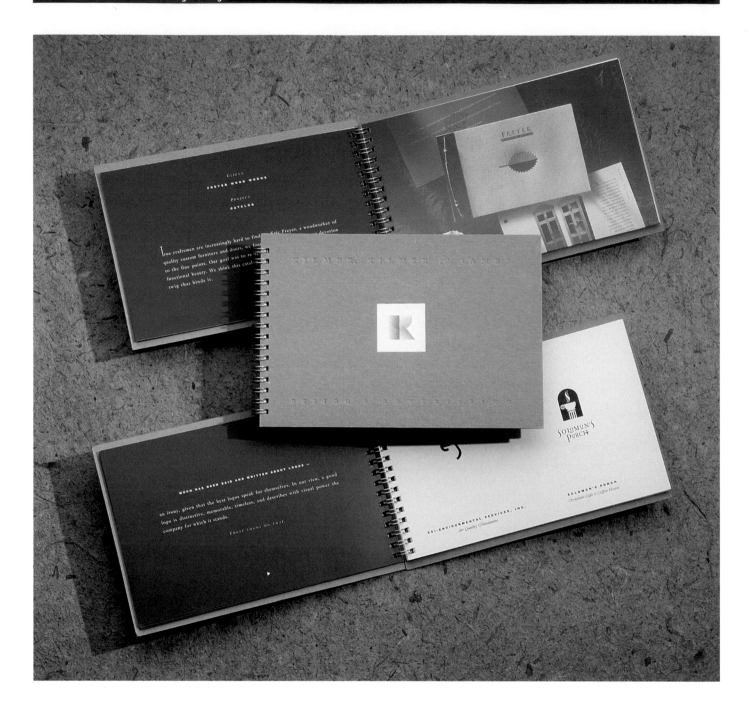

Kilmer & Kilmer, Inc.
Corporate Brochure

Art Director/Studio Richard Kilmer/Kilmer & Kilmer, Inc.
Designers Richard Kilmer, Brenda Kilmer, Randall Marshall
Copywriter Nathan James
Paper LOE, Milkweed Genesis, chipboard
Colors Four-color process, plus a varnish
Typefaces Janson, Helvetica, Univers, Garamond
Printing Offset

Cost No real costs since printing was traded for acknowledgment of printer in the piece.

Concept The innovative cover treatment of this multipage capabilities booklet sets the stage for the various design projects highlighted and profiled inside. The company's name as well as a 1½" x 1½" (3.8cm x 3.8cm) square shape are imprinted on the front chip-

board cover. A square cutout of the company's logo—taken from business cards—is then easily glued in the square shape. Flexible spiral bounding allows for pages featuring new projects to be added easily. Combined with the sturdy chipboard cover, the booklet has staying power.
Cost-Saving Techniques The studio cut out its logo from old business cards to glue to an imprinted square shape on the

cover. Additionally, the 5½" x 8½" (14.0cm x 21.6cm) page format was configured to maximize the press sheet.

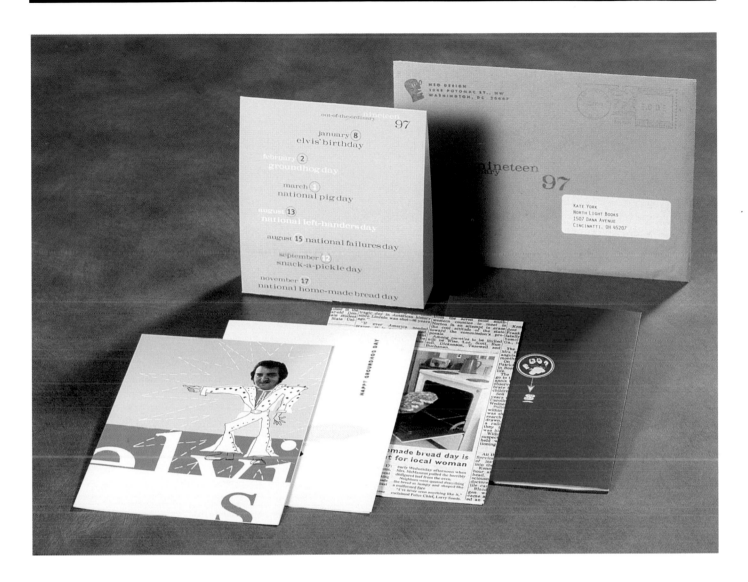

neo design
Holiday Promotion

Art Directors/Studio Harold Riddle, Hunter Wimmer/neo design
Designers Harold Riddle, Hunter Wimmer
Photographer Hunter Wimmer
Paper Vintage Velvet 65# cover, French Speckletone Madera Beach 80# cover, French Speckletone Kraft 80# cover, Neenah Classic Crest Sawgrass 65# cover
Colors Various
Typefaces Craw Modern, Meta, Futura Family, Keedy Sans, Garamond, Univers Family, HeftyFont, Gautane and others
Printing Offset, Xerography
Cost $3,700 for 1,000 packets

Concept This holiday greeting card package follows in the tradition of neo's past lighthearted and satirical promotions. The greeting cards commemorate some of the more obscure "holidays"—such as Elvis's birthday, National Failures Day and National Homemade Bread Day. Designs for each of the cards range from silly to wacky to outrageous, but they're all good for a laugh, or at least a chuckle. Coupled with a stand-up desk calendar, the ensemble is effective at keeping neo's name in front of existing clients and getting it out to potential new ones.

Cost-Saving Techniques Low-cost one-color printing on three cards and four-pass Xerography on another card alleviated color printing costs. The cards and their envelopes were wrapped in hand-cut industrial Tyvek and then packaged in a plain brown Kraft paper envelope that was hand-stamped with the neo logo and address. The stickers of the neo logo used to seal the Tyvek wrapping were ganged with another print run. The many hand-assembly techniques used helped save costs.

Special Visual Effects Four-pass Xerography was used to generate the inset photo on the National Failures Day card. Thermography was used over one PMS color to achieve an unusual visual and physical depth.

Consider Booklet

Art Director/Studio Stewart Monderer/Stewart Monderer Design, Inc.
Designer Aime Lecusay
Photographer Keller and Keller
Paper Gilbert Esse
Colors Three PMS on front side and one PMS on back side
Typeface Din Mittleschrift
Printing Offset, with hand-glued sleeves and hand-stamping
Cost $2.22 per brochure, not including hand assembly and stamping

Concept This accordion-fold, unusual format promotional brochure presents the studio's work and ideology in a stimulating, thought-provoking fashion. On one side, the 5½" x 5½" (14.0cm x 14.0cm), four-fold piece unobtrusively lists the studio's name, copywriter, photog-

rapher and paper stock on a soft bluish-gray background accented with a modest flower design. On the flip side, photos representing the world through the eyes of a child are interpreted with copy that expresses the wonder, innocence and imagination we probably all associate with childhood. The presentation is poignant and moving and subliminally communicates the quality and creativity that goes into each of the studio's design projects. The brochure is contained in a sleeve that's highlighted by the word "Consider" in what appears to be a child's doodling.

Cost-Saving Technique The sleeves were hand-sealed and hand-stamped with the "Consider" image.

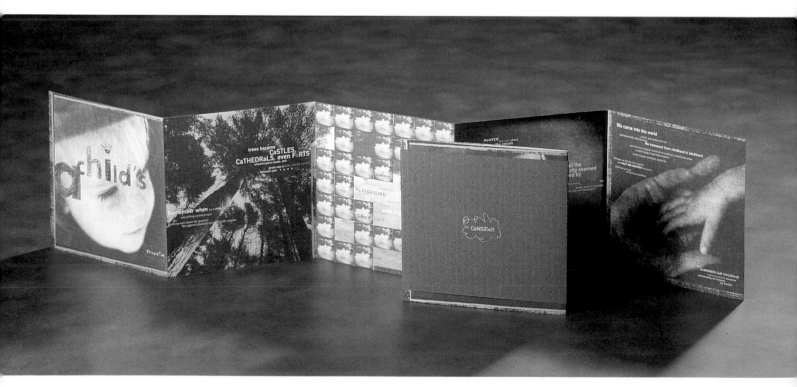

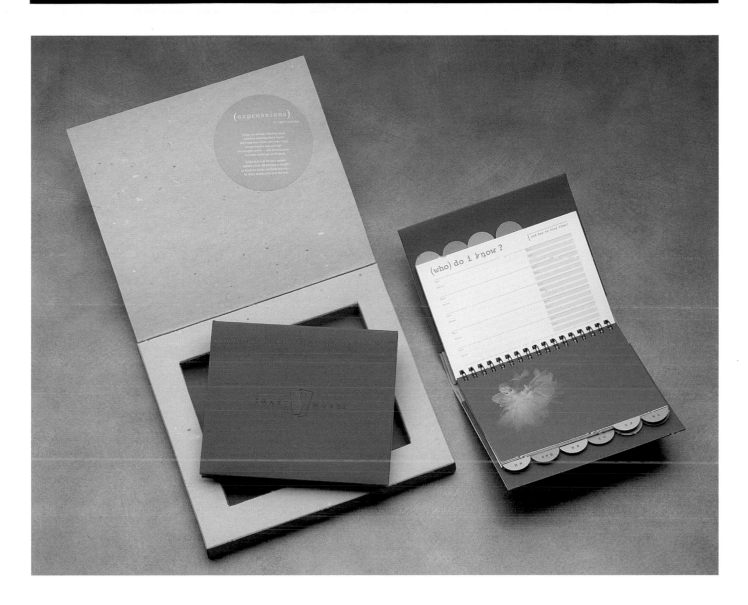

Smart Works
Address Book

Art Director/Studio Jane Jeffrey/ Smart Works Pty Ltd
Designers Jane Jeffrey, Andrea Rutherford, Zan Shadbolt
Photographer Jacqui Henshaw
Paper Options Mulberry Heather; Construction Fuse Green; Options Warm White; Construction Safety Orange; Fuse Green; Dur-O-Tone Packing Carton; Construction Brick Red
Colors Three PMS, two metallic and black
Typefaces Courier, Univers
Printing Offset for text pages and embossing treatment for the cover
Cost $2.98 per piece. The printing and embossing were donated.

Photography was donated and paper supply was donated. Form cutting, hole punching, binding and boxes cost $4,475 for a total print run of 1,500 copies.

Concept This functional holiday gift sent to Smart Works' clients expresses not only the practicality of the studio's creative design solutions, but also the introspective thought and care that goes into every project. The address book is set up like a card file with yellow- and gold-lettered tab pages, each of which features an expression of thought or idea on one side and a graphic or image that represents that expression or idea on

the other side. For example, one of the expressions included is, "The most vivid ideas often blossom from the barest roots." The accompanying image is a photo of a flower in full bloom with droplets of dew on its petals. Measuring 6" x 4¼" (15.2cm x 10.8cm), the spiral-bound address book is inserted in a plum- colored folder that has the studio's logo embossed on its cover. The ensemble is then fitted into a specially designed compartment in a flip-top box. A gold-colored sticker affixed to the inside of the flip top declares the studio's "expression" of appreciation toward its clients.

Cost-Saving Techniques To keep out-of-pocket expenses to a minimum, the studio was able to get the printing, the paper, the photography and the embossing donated in exchange for crediting suppliers on the inside back cover of the address book. Smart Works hand-collated, bound and assembled all books in-house, including the boxing and tying.
Special Production Technique The slipcover has a custom duplex cover to increase its stability and staying power and to coordinate with the rest of the book.

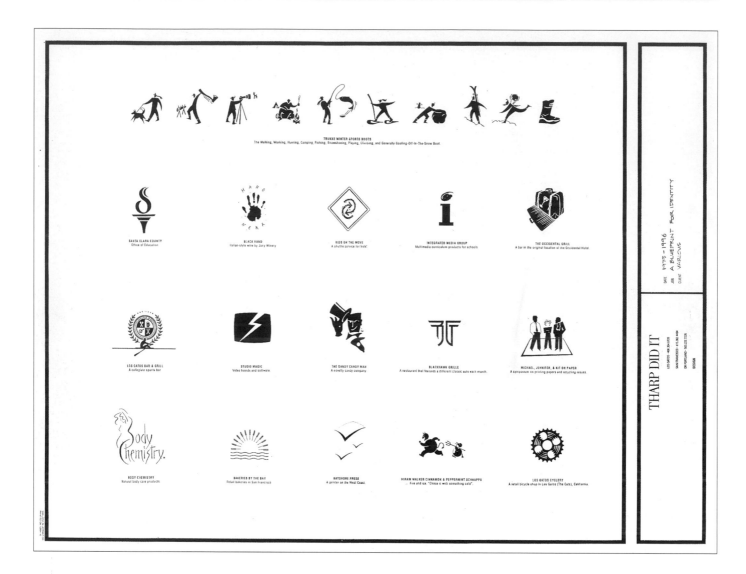

Tharp Did It
Identity Blueprint

Art Director/Studio Rick Tharp/
Tharp Did It
Designer Rick Tharp
Paper Blueprint
Printing Blueprint
Cost $1.50 per blueprint

Concept The concept behind
this self-promotion was to
develop a piece showcasing the
studio's corporate identity work
that could be readily updated at
a relatively low cost. The solu-
tion was this very simplistic yet
imaginative blueprint of proj-
ects. Various identities are
arranged on the sheet along with
the name of the corporation and
its tagline. The format is practi-
cal and pragmatic, while also

quite adequate in showing the
studio's range and talents in
corporate identity work.
Cost-Saving Techniques All the
artwork is created traditionally
(not utilizing a computer). The
process involves making photo-
stats or photocopies of the
logos, pasting them into posi-
tion, and making an inexpensive
blueprint. This eliminates the
need for computer time and
large format linotronic output.
The blueprints are so inexpen-
sive the studio can keep a sup-
ply on hand and send them to
potential clients at a moment's
notice.

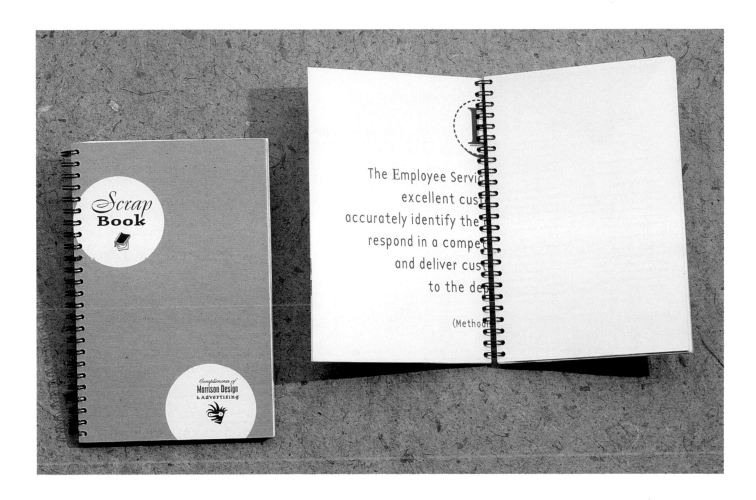

Morrison Design & Advertising Scrapbook

Art Director/Studio Penny Morrison/Morrison Design & Advertising
Paper Various paper samples, chipboard, laser labels, existing business cards
Color Black
Typefaces Boulevard, Snell Roundhand Bold and Black, Journal Ultra Bold, Quartet Bold, Swiss 924 BT, ITC Century Regular and Italic, Big Cheese Light and Dark
Printing Laser
Cost Laser labels were $.25 and binding was about $2 per book

Concept A mountain of old laser copies that had accumulated in the studio's office since it

began using computers to generate design pages was the inspiration for this practical promotional gift to clients. These 5½" x 8½" (14.0cm x 21.6cm) spiral-bound notebooks utilize leftover laser copies and waste paper from various projects completed by the studio. The copies were cut smaller and assembled with the blank side up. On the flip side, recipients get a sampling of the studio's capabilities and range of design skills, as represented by the snippets and fragments from various design projects. A thank-you/explanation message is inserted as the first page in the book while a business card is bound in the back.

Two circular cutouts affixed to the front cover are its only embellishment. The concept is modest and low-key, but sends a strong message to clients about the studio's attention to finding innovative, cost-effective solutions to their design needs.

Cost-Saving Technique The creative work/design already existed.

Special Production Technique The lasers represent a cross section of clients/projects, and are trimmed in halves or quarters.

Hal Apple Design & Communications, Inc. 1995 Holiday Card

Art Director/Studio Hal Apple/ Hal Apple Design & Communications, Inc.
Designer Andrea Del Geurcio
Illustrator/Photographer Jason Hashmi
Paper Canon Fiery
Colors Four-color process
Typefaces Various
Printing Canon Fiery
Cost $.50 each

Concept The theme for this holiday greeting card was based on dreams and the fulfillment of them. As a gift to clients, the studio made a donation in their

name to the "I Have a Dream" Foundation, which awards college scholarships to inner-city youths who graduate from high school. This is explained on the inside of the card, which has the unusual dimensions of 7⅛" x 3" (18.1cm x 7.6cm). The message is placed atop a dreamy— almost haunting—image of clouds with the eyes of a child peering through. Visuals on the plain white front cover represent different meanings of or associations with the holidays, including worship, shopping, snowfall and festivities. The question

"What do the holidays mean to you?" is emblazoned across the four photos, encouraging the reader to open the card and read further. The festivities visual is repeated as a bleed on the back cover of the card.
Cost-Saving Technique Canon Fiery is a high-quality color copying process. Using this printing process versus offset printing saved on film, proofs, etc.
Special Visual Effect Used Photoshop to layer images on the inside of the card.

aire design company
Self-Promotion

Art Director/Studio Catharine
Kim/aire design company
Designers Catharine Kim,
David Kolb, Shari Rykowski,
Matthew Rivera, Kasey O'Leary
Photographers Daniel Snyder
Printing Danmar & Associates
Paper Neenah Classic Laid
Solar White, Carolina CIS 10 pt.
Colors Four-color process plus
spot varnish; one PMS on calen-
dar pages
Typefaces Emigre Not Caslon,
Matrix Script, ITC Officina
Sans
Printing Offset lithography
Cost Budget was $5,000. Actual
costs were $2,944 for printing of
300 calendars, 900 posters and
900 postcards, plus $250 for
binding.

Concept This versatile promo-
tional package was not only a
useful prop for clients' desks,
but it also gave each of the stu-
dio's designers a format to
showcase their individual style.
The project is composed of
three elements: postcards, a cal-
endar and a poster. The twelve
postcards were printed as a
poster and range widely in con-
cept and design. Some feature
the studio's past projects, while
others are more abstract and
personal. The studio name,
address and phone number are
printed on the back of each card.
The poster format is clean and
simple with the postcards
arranged in a block and key
words characterizing the studio
placed to balance the presenta-
tion. Some of the posters were
cut into individual postcards,
which were then placed as
inserts on the one-color calendar
pages. Clients could easily
remove them and still have an
attractive calendar page—fea-
turing a one-color screened ver-
sion of the naturalistic calendar
cover design—to look at. This
sophisticated, well-planned pro-
motion reflects the studio's
design ingenuity while keeping
its name in front of clients
throughout the year.

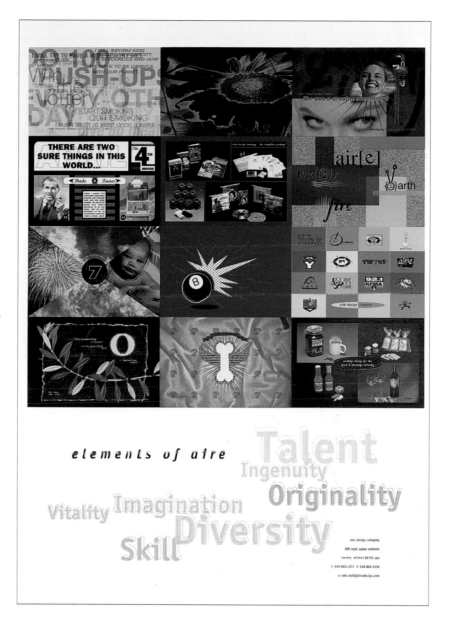

Cost-Saving Techniques The
calendar pages are one color.
The calendar cover was ganged
on the same sheet as the poster.
Staff hand-assembled calendar
pages and used the studio's own
binding machine. The studio's
print rep bought some calendars
for her own promotion, which
offset film costs. Last, the use of
stock envelopes to mail the cal-
endars helped cut costs.
Special Production Technique
Reverse varnish is used on the
calendar cover to emphasize the
names of the months that appear
down the right side.

EDG Holiday Candles Promotion

Art Director/Studio Stan Evenson/Evenson Design Group (EDG)
Designer Amy Hershman
Photographer Anthony Nex
Paper Classic Columns Natural White
Colors Two
Typefaces Berkeley Book, Letter Gothic
Printing Lithography
Cost $6.66 per unit

Concept This holiday promotional gift sends a warm, thoughtful message of love, peace and prosperity for the new year to Evenson's clients. The concept relates the three candles to the tradition of lighting candles at holiday time. Colors of the candles were carefully chosen to represent the ideas of love (red), peace (blue) and prosperity (green). Bound with a textured fabric-like paper and plain twine, the candles are nestled in a neutral-tone bed of shredded paper and packaged in a box covered in the same neutral tone paper. A modest five-page greeting card, measuring 7" x 2⅛" (17.8cm x 5.4cm), displays the three words of love, peace and prosperity imprinted with a varnish, along with a short, simple greeting in black from the studio.

Cost-Saving Techniques The studio was able to purchase the candles for very little. The printing was only black with a varnish on a recycled stock.

Special Production Techniques An old-fashioned wax seal helped secure the three candles bound in twine. The box to house the candles was wrapped in a natural recycled paper stock. The booklet delivering the message was printed subtly with black and a varnish.

Visual/Verbal Holiday Card

Art Director/Studio Eric Kass/ Eric Kass Design
Designer Eric Kass
Paper French Dur-O-Tone Newsprint
Colors Three
Typeface Stemple Garamond
Printing Laser, plus rubber stamping
Cost $10 for rubber stamps and pads, plus postage

Concept You might characterize the design of this holiday promotion and Kass's moving announcement below as matter-of-fact and to the point. The front of this card is a sarcastic comment on the somewhat overzealous trend of late to be politically correct. On the back of this card is an equally poignant and glib statement on the true reason for the season. To top it all off, and perhaps add a little color to the card, the designer chose a showy (almost gaudy) Santa Claus stamp for mailing the card.

Cost-Saving Techniques The card was laser-printed, rubber-stamped and hand-assembled. The chipboard was free packing material, which proved useful in creating a generic, nondescript feel. Postcard format saves on postage and has an immediate impact in the mail.

Special Production Technique Rubber stamping the dates on the card gives a personalized feel while adding low-cost color.

"Moved Around the Corner" Announcement

Art Director/Studio Eric Kass/ Eric Kass Design
Designer Eric Kass
Paper French Dur-O-Tone Newsprint
Color One
Typeface Stemple Garamond
Printing Laser

Cost $5 for envelopes, plus postage

Concept Like the holiday card greeting above, Kass takes a glib, unpretentious approach to announcing to clients that the studio has moved its offices. The move was short—practically just around the corner. So, the announcement, too, was designed to be short and to signify the new location. Using a postcard format, the letters "Mo" are positioned to bleed off the right edge of the card. Flip the card over right to left and the letters "ved" complete the message. The concept is simple, yet unique, and communicates to clients that the designer understands their need to get useful information quickly.

Cost-Saving Technique Cards were laser-printed.

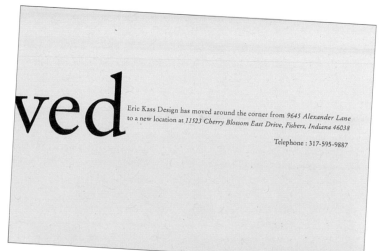

Greteman Group
Holiday Card

Art Director/Studio Sonia
Greteman/Greteman Group
Designers James Strange, Sonia
Greteman
Paper Corrugated cardboard
Color Black
Printing Rubber stamping
Cost $50 for grommets, card-
board and rubber stamping of
about 150 cards

Concept As the studio staff
began planning the design for
their annual holiday promotion,
they were tempted to pull out all
the stops and send a glitzy,
showy piece that demonstrated
their artistic and creative talents.
But, then it occurred to them
that something simple and from

the heart might be more appro-
priate and more in line with the
true spirit of the season. So,
they put together this modest,
unadorned card displaying an
equally modest message of
"peace, love, and joy." The cor-
rugated cardboard is folded
once to a finished size of 5" x 7"
(12.7cm x 17.8cm), and fas-
tened with a nut and bolt.
Although the staff chose not to
publicize this, they donated, in
their clients' names, the money
they would have spent on a
more extravagant promotion.
Cost-Saving Technique
Corrugated cardboard and rub-
ber stamping proved to be very
inexpensive.

Fresh Promo Book

Studio Fresh Design
Designer Glenn Sweitzer
Illustrator Glenn Sweitzer
Production Coordinator Sheri Sweitzer
Printing Sir Speedy
Paper Confetti; Karma 100# White
Colors Two PMS
Typefaces Bodoni, Phoenix #9
Printing Offset
Cost $4.56 per book. 500 were printed for a total of $2,280. Printing costs were $1,800, film costs were $400 and screw posts cost $80.

Concept The design of this miniportfolio draws from the studio's name—and appropriately so since it showcases the firm's corporate identity and logo work. Measuring 7¼ inches (18.4cm) square, various samples of different identities and logos are reproduced in two colors and positioned one and two per page on a textural white paper. The design is clean and uncluttered, allowing the logos and identities to take center stage. The opening page is a piece of clear acetate with a one-color image of a pizza—signifying freshness—printed on it. The studio's name and address is printed in black on the next page which is visible through the acetate. In all, there are nineteen pages, which are bound by two screws in a plum-colored folder accentuated by a die cut of a slice of pizza.

Cost-Saving Techniques All pages were printed and drilled separately. Each book is put together by hand and can be customized or added to without printing an entire book. The clear page in front was printed on the studio's Tektronix printer. Binding was done using aluminum screw posts.

Special Visual Effects The cover has a die cut along with a foil embossing. The printed image of the pizza shows through the opening on the cover.

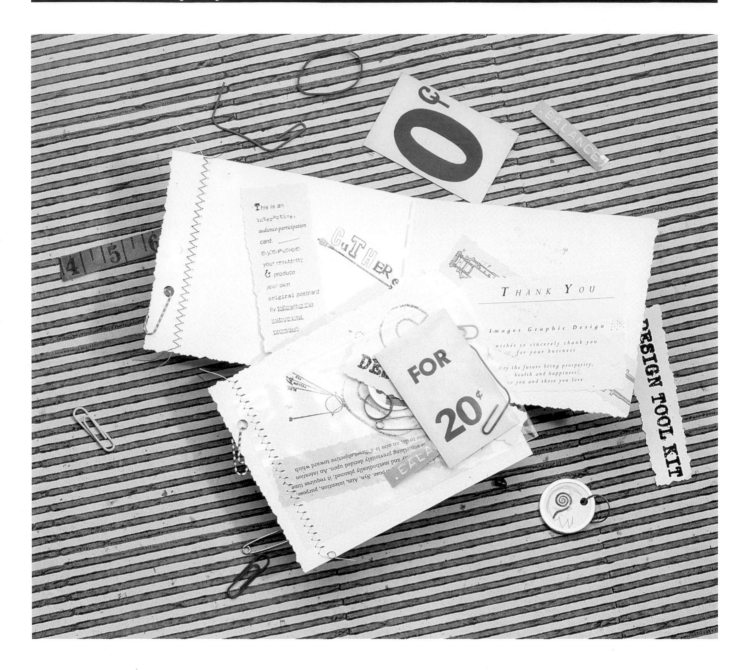

Client Thank-You Card

Art Director/Studio Sondra H. Phillips/Images Graphic Design
Designer Sondra H. Phillips
Illustrator Sondra H. Phillips
Paper LaserJet Husk
Typefaces Various
Printing Laser
Cost Paper samples were free. The average cost of the items included in the plastic sleeve totals between $2 and $3 per card.

Concept This special holiday gift for clients doubles as a thank-you card. To encourage clients to participate in the design process, the studio assembled a variety of doodads that recipients could use to design their own postcard. The goodies are bagged in a clear plastic sleeve, which is then stitched to the front of the card. A definition of the word "design" is affixed to the card's front cover. Inside the card, a hodgepodge of messages and images printed on paper scraps are affixed to the card with glue and staples. The package truly speaks to the studio's unique style and individuality, while at the same time symbolizing the value placed on the client/designer relationship.

Cost-Saving Technique The card was created with paper samples left over from other jobs, which provided a wide range of colors and textures.

Special Visual Effect Special visual effects were provided by the doodads contained in the plastic sleeve. It turns a simple card into a three-dimensional sculpture.

Special Production Technique All cards were assembled by hand and a sewing machine was used for the zigzag stitching.

POSTERS

Canal Days Poster

Art Director/Studio Eric Kass/
Eric Kass Design
Designer Eric Kass
Photographer Bass Photo
Company Collection, Indiana
Historical Society
Printing Spectrum Press
Client/Service Broad Ripple
Merchants/Business association
Paper Warren Lustro Dull
Cream
Colors Black, brown, plus dull
and gloss varnish
Typefaces News Gothic, Texas
Hero
Printing Offset
Cost $850 for printing, $12 for
photographs. Design work
donated.

Concept The designer aimed for
a historical feel in creating a
16½" x 22" (41.9cm x 55.9cm)
poster promoting an art gallery
tour and street fair in a historic/
artsy neighborhood of
Indianapolis called Broad
Ripple. He achieved it, at very
low cost, by buying photographs
from the Indiana Historical
Society Library showing neigh-
borhood scenes from 1837
(bridge over the canal), 1908
(train tracks through town) and
1938 (swimmers at Broad
Ripple Park). The historical
content was further highlighted
by the use of varnishes to set off
the type and give the photos a
photoprint look. The nontradi-
tional composition of the poster
helped create a striking piece to
generate interest in the event
among both traditional and
quirky potential audience
members.
Cost-Saving Technique Using
photos from the Indiana His-
torical Society saved consider-
able funds.
Special Visual Effect Use of
dull and gloss varnishes helped
to provide a photoprint look.

XI Mostra da Gravura de Curitiba Poster

Art Director/Studio Silvio Silva Jr./Studio Lumen
Designer Silvio Silva Jr.
Illustrator Silvio Silva Jr.
Client/Service Curitiba Cultural Foundation/City arts organization
Paper Fabric
Colors Four-color process
Typefaces Compacta, altered via Xerox copies and in Adobe Photoshop
Printing Serigraphy
Cost $2 each piece for 400 posters

Concept Mostra da Gravura is a major event in Brazil, bringing together the work of such artists as Warhol, Matisse and Mapplethorpe from a total of fifteen countries. But the budget for promoting the eleventh show was tight. To combat that, the designer used a low-cost fabric called Kami for the posters, printing them in silkscreen by local artists involved in the event. The use of fabric—combined with a hand print and layers of headline type in the background—gives the finished piece a textured, etched feeling.
Cost-Saving Technique The use of a low-cost fabric for the poster eliminated the need for paper and films.
Special Visual Effect The use of fabric lent a textural feel to the etching-like images.
Special Production Techniques The images were printed on a scanjet plotter on polyester. Each silkscreen required six tints, applied in two parts because of the poster's large dimensions.

Wexner Center Film and Video Poster Series

Art Director/Studio Terry Alan Rohrbach/Wexner Center for the Arts
Designers Terry Alan Rohrbach, M. Christopher Jones
Client/Service Wexner Center for the Arts/Cultural and arts organization
Paper Blackline Diazo
Color Black
Typefaces Various
Printing Blackline Diazo
Cost $.10 per piece

Concept The Wexner Center for the Arts sought to capture attention and create interest in its eclectic mix of cinema with a series of black-and-white mini-billboards. The pieces were designed to be posted around the Ohio State University campus, as well as the surrounding community of Columbus, Ohio. The posters draw upon imagery associated with each film. A poster featuring a series of film noir screenings, for example, incorporates the distressed visages of some of the films' stars into the headline type. Each 11" x 17" (27.9cm x 43.2cm) poster—there are five in all—includes a dominant headline, a synopsis of the films in the series and information about attending the film (date, time, place, cost, etc.). The copy reads like minimovie reviews, bringing the reader back to campus and the days of diverse, plentiful and cheap film offerings.

Cost-Saving Techniques All imagery was scanned in-house on a desktop scanner. The film was output directly from disk and supplied to an imaging service. The curves in images were adjusted to combat the tendency of black lines to lose contrast. The film was output at 100 dpi.

Special Visual Effects The use of black-and-white only imagery, combined with sometimes grainy artwork, gives the pieces an on-the-edge feel.

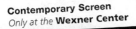

Contemporary Screen
Only at the **Wexner Center**

PROMORAMA
JENNI OLSEN

THU, JUN 20, 7 PM
Media producer Jenni Olsen resurrects long-unseen "coming attractions" trailers and recycles them into funny and oddly compelling programs. *Homo Promo* (1992), Olsen's first compilation, presents a crash-course overview of nearly every mainstream gay or lesbian-themed Hollywood movie from 1956 to 1976. *Trailer Camp* (1995) highlights low-budget classics of kitsch and camp. (Program: app. 2 hrs)

TOKYO COWBOY
KATHY GARRISON

FRI–SAT, JUN 21–22, 7 PM
In this light-hearted, gender bending romp, a young Japanese burger flipper named No Ogawa heads to Canada, seeking a place where people still rope dogies and wear cowboy hats. When No reunites with his childhood pen-pal, Kate, and meets Kate's lesbian lover, Kate's mother, and the local letter carrier, he discovers that the West is wilder than he'd ever imagined! (Film: 94 mins.)

FRISK
TODD VEROW

THU–SAT, JUN 27–29, 7 PM
Mature subject matter, viewer discretion is advised. The most controversial gay-themed film to appear, Todd Verow's *Frisk* has been praised as a searing AIDS gay psychology. Based on Dennis Cooper novel, *Frisk* tells the story of Dennis, its central stylish ambiguity and a darkly ironic tone. With Alexis Arquette, Parker Posey. (Film: 83 mins.)

Call **292-2354** for tickets
or TicketMaster at 451-3600.

Admission
$5 general public
$4 Wexner Center members,

only at the **Wexner Center**

Melton Center
Matinees

The Magic of Place: Jewish Films from Around the World

Enjoy the very best in contemporary Jewish film and lively discussions with OSU scholars following each film.

Cosponsored by O.S.U.'s Melton Center for Jewish Studies.

Sun, Feb 2 / 2 pm
Carpati: 50 Miles, 50 Years
Focusing on the last stronghold of Jewish life in the Ukraine's Carpathian Mountains, Carpati offers a bittersweet look at a "proste yid's" (simple Jew's) interaction with his gypsy neighbors. Followed by discussion with Profs. David Miller (Yiddish) and Katherine David (or History).

Sun, Feb 9 / 2 pm
Like a Bridge
This feature tells the lively story of two young women coming of age in Mexico City's Jewish community in the 1980s and 1960s. Followed by discussion with Profs. G. Micheal Riley (History), Ingneeic Cerena (Spanish and Portuguese), and Cathy Rakowski (Women's Studies).

Sun, Feb 23 / 2 pm
Saint Clara
Winner of six awards from the Israeli Academy of Motion Pictures, Saint Clara tells the story of a Russian immigrant girl gifted with psychic powers to explore a fresh, radically universalized vision of Israeli society. Followed by discussion with Profs. Shalom Goldman (Hebrew) and Michael Swartz (Hebrew).

Call **292-3535** for ticket information
or TicketMaster at 431-3600.
Admission $5 general public $4 Wexner Center members, students, senior citizens $2 children under 12

wexner center for the arts the ohio state university

Satyajit Ray who received an Academy Award for Lifetime Achievement in 1992 shortly before his death, put Indian cinema on the world map. His films, which have won fans across the globe, eloquently and compassionately express the humanity of ordinary people living day by day. Thanks to the efforts of Ismail Merchant—the producing partner of the acclaimed Merchant Ivory film team—the cinema of this Indian master is being preserved and once again celebrated worldwide. This program of nine Ray masterpieces is sponsored by Merchant Ivory Productions, in partnership with Sony Pictures Classics.

Pather Panchali (1955)
Sat, May 4, 7 pm
A realistic study of a poverty-stricken Indian family in Bengal, the film is the first of Ray's acclaimed "Apu trilogy" based on the popular book by Bibhuti Bhushan Bannerjee. The film's score is by Ravi Shankar. (115 mins.)

Aparajito (1956)
The World of Apu (1958)
Wed, May 8, 7 pm
Aparajito, the second film of Ray's "Apu trilogy," examines the relationship between Apu and his mother, as well as his life in the country and city. (113 mins.) Apu finds a wife and begins a family in the partly altered or Apu, the final film in the trilogy. (105 mins.)

The Music Room (1958)
Charulata (aka The Lonely Wife, 1964)
Sat, May 11, 7 pm
In The Music Room, an aristocratic landowner, forced to sell his crumbling mansion because of his extravagances, decides to spend the remains of his fortune on a last concert in own rich feudal estate. (100 mins.) The speed and sophistication of a 19th-century aristocrat finds herself falling for a young poet in Charulata. (120 mins.)

Devi (aka The Goddess, 1960)
The Big City (1963)
Wed, May 15, 7 pm
A young woman is convinced by her fanatical father-in-law that she is the reincarnation of the goddess Kali in Devi. (93 mins.) In The Big City, the wife of a poor bank clerk finds personal freedom when she takes a job selling sewing machines to rich housewives in Calcutta. (136 mins.)

Two Daughters (1961)
The Middleman (1975)
Sat, May 18, 7 pm
Based on stories by Rabindranath Tagore, Two Daughters is Ray's two-episode homage to the Nobel Prize-winning author on the centenary of his birth. (114 mins.) In The Middleman, Ray's harsh commentary on contemporary Indian society, a young college graduate, desperate for work, takes a position in a corrupt business. (135 mins.)

cinematheque
only at the wexner center
Cosponsored by OSU's Office of Asian American Student Services

Satyajit Ray

Admission
$5 general public
$4 Wexner Center members, students, senior citizens
$2 children under 12

All screenings are in the Wexner Center Film/Video Theater

Call **292-2354** for ticket information

wexner center
for the arts
the ohio state university
n high st at 15th ave

Coffee Pot Volcano Poster

Art Director/Studio John Sayles/
Sayles Graphic Design
Designer John Sayles
Illustrator John Sayles
Client/Service Timbuktuu
Coffee Bar/restaurant
Paper Kraft feedbags
Colors Two PMS colors
Typeface Hand-lettering
Printing Screen printing
Cost $8 per poster

Concept When Charlie Bienert
opened the Timbuktuu Coffee
Bar in Des Moines, Iowa, in
1995, he wanted one designer to
handle the logo, signs, market-
ing, packaging, poster, tables,
chairs and staff T-shirts. He
even called on the designer to
help name the coffee bar. The
result: a comprehensive, cohe-
sive corporate identity cam-
paign for an upscale coffee
business and a concept ready-
made for franchising. For this
16" x 35" (40.6cm x 88.9cm)
poster, titled "Coffee Pot
Volcano," the designers bor-
rowed elements used throughout
the coffee bar. The three "bean
men" dancing on the coffee
pot—complete with coffee
bean-shaped heads—can be
seen on tabletops, table supports
and printed materials in the
store. The colors and paper
selected for the poster are
repeated in the store. So, too, is
the "tribal" mask on the coffee
cup, the hand-lettered coffee
selections bordering the margins
and the business logo tucked
into the lower left corner.
Cost-Saving Technique The
designers used pre-made Kraft
feedbags as paper stock, both to
cut costs and create an unusual
visual statement.
Special Visual Effect The
unusual poster size enhances
the long, narrow nature of the
illustration.

Kilmer & Kilmer Inc.
Truman Poster

Art Director/Studio Brenda Kilmer/Kilmer & Kilmer Inc.
Designers Brenda Kilmer, Richard Kilmer, Randall Marshall
Copywriter Nathan James
Client Kilmer & Kilmer Inc.
Paper Genesis Tallow 80# cover
Colors Two
Typefaces Various
Printing Silkscreen
Cost $645 for printing

Concept This Albuquerque, New Mexico, design firm played off its new street address to announce an open-house party. Adopting the style of political handbills, the designers used the word "Truman" at the top of the 15" x 36" (38.1cm x 91.4cm) invitation to both set the tone and impart their news. They scanned the famous image of a famous headline—President Truman holding up a newspaper that wrongly declared "Dewey defeats Truman"—and altered the type to note their own move. ("KK&J" in the headline refers to the agency's previous name.) A red, white and blue motif, with a stars-and-stripes design, continued the political allusion, while political catch phrases ("forming another party," "inaugurate" a new building, "vote early and vote often") completed the gag.
Cost-Saving Technique The designers built a mechanical using a combination of laser proofs and photocopies, shooting it on a single sheet of film and separating the colors by hand.
Special Production Technique To create the feel of an old political poster, the designers left lines and other imperfections on the mechanical, even enhancing some of them for effect.

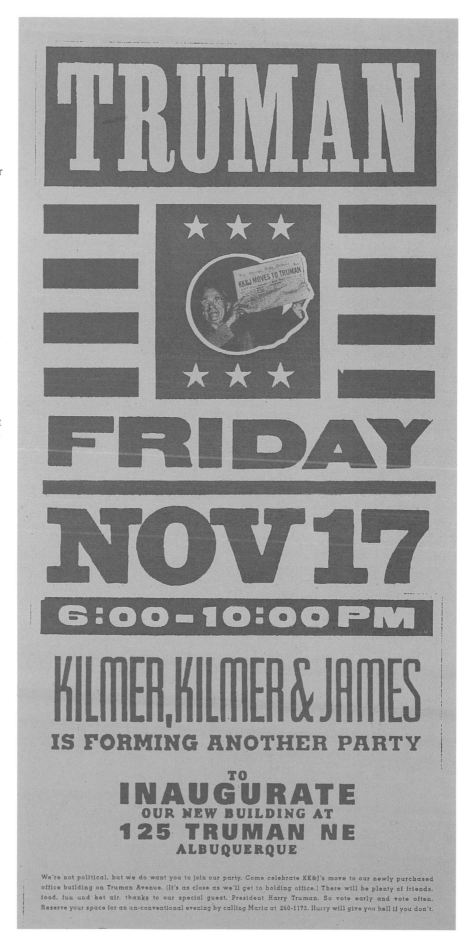

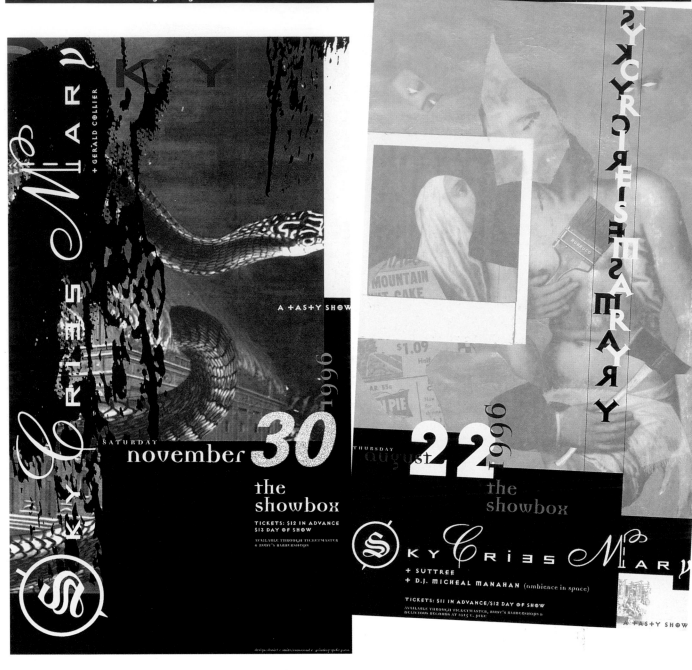

Sky Cries Mary Posters

Art Director/Studio Daniel R. Smith/Command Z
Designer Daniel R. Smith
Illustrator Daniel R. Smith
Client/Service Tasty Shows/Concert promoter
Printer Risa Blythe/Girlie Press
Colors Black and one PMS
Typefaces Democratica, Excocet, Univers
Printing Offset
Cost $125 for design work; $175 for paper and film

Concept Despite a long history of postering in the Seattle market, the Seattle City Council no longer allows posters on telephone poles in the city. Ironically, the prohibition has, in some ways, made poster design and printing more important there. Instead of producing a thousand photocopy posters, bands and clubs are now more inclined to print one hundred or two hundred to hang in coffee houses and record stores. The result: Poster makers are often replacing quantity with quality. The Tasty Shows posters provide a prime example. The sophisticated typefaces, the arresting design and the heavy paper stock grab the attention like no telephone-pole piece could. The client's instructions to the designer were simple: Make it funky. Command Z achieved that goal, and the result is a cut above the usual telephone-pole flyer for a band performance.

Cost-Saving Technique The designer took advantage of a volume deal between the concert's promoter and its printer, using two-color printing and completing the job without press checks, bluelines or matchprints.

Special Visual Effects For the August poster, the special effect is achieved via scanned paper collage with overprinted bitmap noise. The color is achieved with black overprints on the red-wine image. For the November poster, the paper collage work provides a textural quality to the posters.

Mountain Laurels Poster

Art Director/Studio Lanny
Sommese/Sommese Design
Designer Lanny Sommese
Illustrator Lanny Sommese
Client/Service State
College/Municipality
Paper Consolidated
Productolith 80# Text
Colors Black and PMS 2725
Typefaces Modula, hand-
lettering
Printing Offset
Cost 1,000 copies of poster
printed for $1,900. Design work
pro bono.

Concept The designer of this
poster for a centennial concert
for the city of State College,
Pennsylvania, faced several
challenges. He was called on to
create a poster that could both
promote an event and commem-
orate it. He needed an image
that would translate well to con-
cert programs and buttons. And,
because of budget restraints, he
could use only two colors. The
result: A 24" x 36" (61.0cm x
91.4cm) poster dominated by an
image of mountain laurels—a
flowering plant prevalent in the
State College area and the name
selected for the concert. The
designer tied the plant and the
music together by forming a
treble clef from the plant's stem
and a musical staff as the plant's
soil. With minimal space given
over to type, the poster is appro-
priate for framing and thus
works as a piece of commemo-
rative art.
Cost-Saving Technique The
client limited color choices and
the designer donated his work.
Special Visual Effect The
designer created a "glow" com-
ing from the blossoms of the
plant and from the earth with
spray paint.

Duluth Playhouse 1996-97 Season Posters

Art Director/Studio Gunnar Swanson/Gunnar Swanson Design Office
Designer Gunnar Swanson
Illustrator Gunnar Swanson
Photographer Gunnar Swanson
Logo Design Gunnar Swanson
Client/Service Duluth Playhouse/Theater productions
Paper Fraser Genesis
Colors Two PMS per poster. Two posters also used metallic ink
Typefaces Adobe Garamond and Quick Type, with Bernhard Modern on "Anything Goes" and Caslon on "Our Town"
Printing Offset
Cost $.67 per poster, with reduced-fee charges for design work

Concept The designer worked to set the proper tone for each play in this series, approaching each of the seven different 11" x 17" (27.9cm x 43.2cm) posters as one part of a whole. Accordingly, each poster follows a similar design: The play title, author and director top the poster, with a clever copy block placed near the center and the playhouse logo and performance information in the lower left. Similarly, each poster features deliberately muted hues, selected to contrast with more common black-and-white and brightly colored playhouse bills. The designer also made sure that one ink color in each poster matched the paper color of at least one other poster, to further unify the pieces.

Cost-Saving Techniques The posters were printed in sets of two. The designer handled all illustration work.

Special Visual Effect The quilt photo on the "Quilters" poster came from a direct scan of a quilt placed on a flatbed scanner.

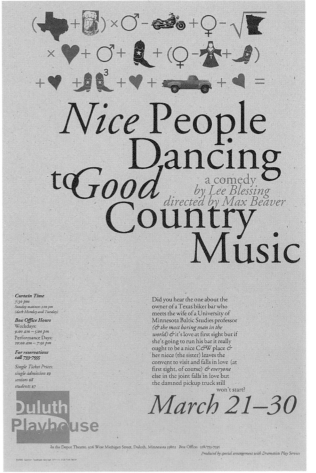

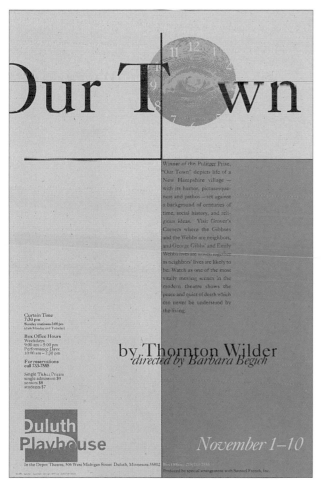

Volks Theatre
Turandot Poster

Art Director/Studio Lanny
Sommese/Sommese Design
Designer Lanny Sommese
Illustrator Lanny Sommese
Client/Service Volks Theatre/
Theater productions
Paper Zanders
Colors Black and PMS 5285
Typeface Hand-lettering
Printing Offset
Cost $1 each

Concept This poster was part of
a project where designers from
different countries were invited
to complete posters for the
Volks Theatre in Rostock,
Germany. With the instructions
to use two colors (of the design-
er's choice) and a standard
poster size, the designer of this
piece for performances of the
opera *Turnadot* used a "simulta-
neous edge" illustration: The
edges of the hand are also the
profile of two faces. The design
reflected the content of the
show—a famous Giacomo
Puccini work about a Chinese
princess who beheads her suit-
ors—with the dagger-like fin-
gernails representing the evil
princess and the faces of the
men who love her. The design
required only simple production
methods; that was important
because the poster was printed
in Germany, barring the design-
er from addressing problems
related to language translation
and from seeing the poster
through the printing process.
Cost-Saving Techniques
Limited color and lighter-
weight paper stock reduced
costs. Printing the poster in
Germany was also a cost-saver.
Special Visual Effect The illus-
tration used a simultaneous edge
to created an arresting visual
image.

Cahan & Associates
"It's No Secret" Poster

Art Director/Studio Bill Cahan/
Cahan & Associates
Designer Craig Clark
Client/Service San Francisco
Creative Alliance/Design
consortium
Paper Fox River Tree Natural
Colors Four-color process
Typeface Futura
Printing Lithography
Cost According to the designer,

no out-of-pocket costs were
incurred.

Concept This offbeat poster
serves as an invitation sent to
the San Francisco design com-
munity to participate in an
evening of lively discussion and
entertainment with Cahan &
Associates. The event was spon-
sored by the San Francisco

Creative Alliance to promote
communication and interaction
among the local creative com-
munity. Art director Bill Cahan
was a featured speaker at this
event. The poster is fashioned
after a 1950s-type grocery store
tabloid. Loud, boisterous head-
lines and blurbs dominate the
busy design that's typical of
tabloids. It's balanced by bold

red, blue and yellow colors, and
a few droll, black-and-white
photos that further support the
staged, sometimes contrived
format of tabloids, past and
present.
Cost-Saving Technique Poster
was printed for free, which pro-
vided great visibility for the
printer.

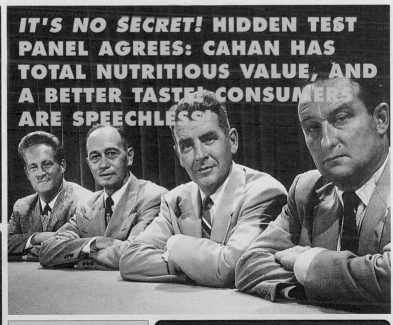

John Sayles and Sheree Clark in High Gear Poster

Art Director/Studio John Sayles/
Sayles Graphic Design
Designer John Sayles
Illustrator John Sayles
Client/Service Detroit AIGA/
Professional organization
Paper Curtis Riblaid Black 65#
Color One PMS
Typefaces Avant Garde,
hand-lettering
Printing Screen printing
Cost $1/piece

Concept When this designer
and his partner were invited
to speak at a meeting of the
Detroit area graphic designers
group, AIGA, he designed a
poster with a streamlined Art
Deco motif. The Des Moines,
Iowa-based designer opted for a
driving theme, in a piece titled
"John Sayles and Sheree Clark
in High Gear," to reflect
Detroit's "Motor City" moniker.
In addition, the designer is a
fan of art from the 1930s and
1940s, so he took advantage of
this self-promotion piece to
draw a forties-style convertible.
He furthered the vintage look of
the poster—and held down
costs to boot—by printing in
silver ink on black cover stock.
Cost-Saving Technique The use
of one ink color saved costs.
Special Visual Effect The use
of silver opaque ink on black
paper provided a sleek image.

PRO BONO

Call-for-Entries Poster

Art Director/Studio Frank Viva/Viva Dolan Communications & Design
Designer Frank Viva
Illustrator Frank Viva
Client/Service Advertising & Design Club of Canada/Professional association
Paper Supreme Matte
Colors Four-color process, silver PMS
Typefaces Franklin Gothic, hand-lettering
Printing Lithography
Cost Design and production donated

Concept Ah, the contest debate! To enter or not to enter, that is the question. The designer of this pro bono project pokes fun at the whole process with a series of fanciful and farcical reasons to enter the Advertising & Design Club of Canada's show. Among them: "I enter because I'm short and fat and this is the only way I can get attention." Another: "I'll enter because I used my influence to fill the judging panel with my cronies." The image of a working stiff, slaving away at his desk, plays deadpan to the jokes emanating from his head. The text at the bottom of the 23" x 36" (58.4cm x 91.4cm) piece provides the needed information about the contest and how to enter.

Cost-Saving Techniques The paper, printing and film were all donated by suppliers. The designer, who also worked for free, scanned and manipulated the piece in-house and provided the job on disk to the printer.

Special Visual Effect The illustration was created in Adobe Photoshop.

Special Production Technique The printing was done with a stochastic screen.

LEAP Sand Castle Classic Poster and Invitation

Art Director/Studio Madeleine Corson/Madeleine Corson Design
Designers Madeleine Corson, Beth Folkerth, Pamela Jeter
Photographer Thomas Heinser
Client/Service LEAP . . . imagination in learning/Nonprofit agency
Paper Coronado SST
Colors Four-color process
Typeface Adobe Garamond

Printing Lithography, sheetfed
Cost All donated

Concept The designer for this pro bono project used the image of adult hands guiding a child's hands in the sand to both communicate the event—a sand-castle building competition—and the client, a nonprofit group that, among other things, sponsors a mentoring program. The hands image, captured with an 8x10 camera, dominates both a 16" x 22" (40.6cm x 55.9cm) poster promoting the fund-raising competition and the cover of a 4½" x 6¼" (11.4cm x 15.9cm) tri-fold invitation to the event. The image is apt considering that San Francisco-area architecture, building and design firms work with local elementary schools to build the sand castles, all for the benefit of LEAP's Artists/Architects-in-Schools Programs.

Cost-Saving Technique Limiting pieces to four-color process held down costs.

Special Production Technique The photographer used an 8x10 camera to capture the primary image for the poster and invitation.

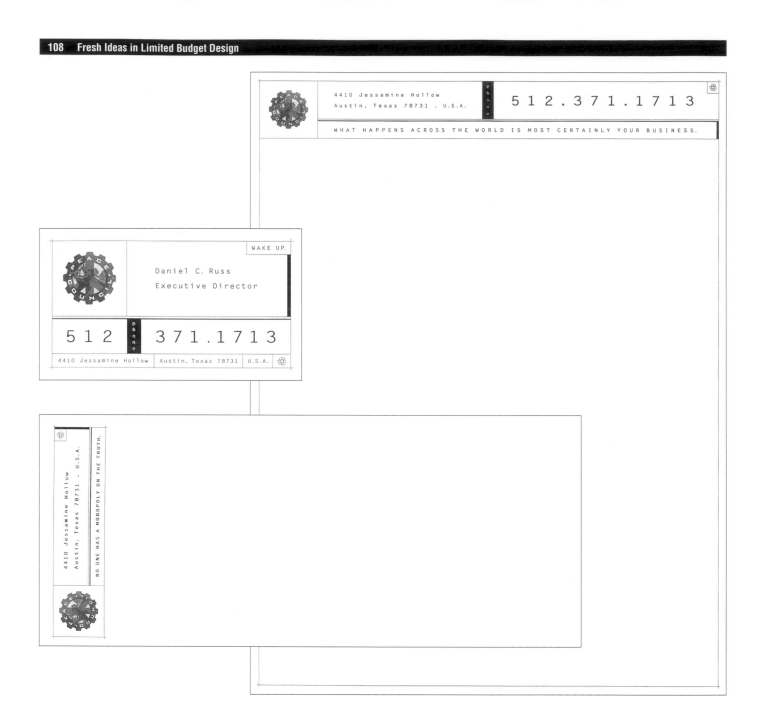

The Peace Council
Identity System

Art Director/Studio Brett Stiles/
GSD&M Advertising
Designer Brett Stiles
Copywriter Daniel Russ
Client/Service The Peace
Council/Nonprofit foundation
Paper Cougar Opaque Vellum
70# Text; 80# Cover
Colors Two PMS
Typefaces Bank Gothic, Letter
Gothic
Printing Offset
Cost Printing, paper and films =
$990; design donated.

Concept The Peace Council, an
Austin, Texas-based foundation
that speaks for those who have
no voice, wanted a letterhead
package that looked official
without being boring or corpo-
rate. The designer accomplished
that goal by combining standard
elements—logo, name, address,
etc.—with an unconventional
layout. Most unusual was the
addition of statements of philos-
ophy. The executive director's
card for example says: "Wake

up." The stationery intones:
"What happens across the world
is most certainly your business."
And the envelopes declare: "No
one has a monopoly on the
truth." The statements reflect
the purpose of The Peace
Council, which, among other
things, aids prisoners who have
been raped or are wrongly
incarcerated; civilians who step
on land mines; and communities
which have been wronged by
the government.

Cost-Saving Techniques The
designer limited the project to
two colors, avoided bleeds and
selected a cost-effective paper
stock to stay under the project's
$1,000 budget.
Special Production Technique
The logo was printed as a
duotone.

Madison Square Boys & Girls Club Annual Report

Art Director/Studio Thilo von Debschitz/Q Design
Designer Thilo von Debschitz
Photographers Clarence E. Bailey, Patrisha Thomson
Retouching Ivan Kolovrat
Printer Hellersche Druckerei
Client/Service Madison Square Boys & Girls Club/Service organization
Paper Countryside, Keaykolour
Colors Black and PMS orange
Typefaces Celestia, Oblong
Printing Offset
Cost $3 per copy for 2,000 copies; design, cover photo, typesetting, retouching, films and delivery from Germany to New York donated; paper, printing and binding at cost.

Concept The German designer of this twenty-page, 8½" x 11" (21.6cm x 27.9cm) book volunteered his services after attending a fund-raiser for the Madison Square Boys & Girls Club while visiting New York City. Working with the club's marketing and communications director, he pulled together text, statistics, first-person stories, amateur photography and children's quotes and poems with the theme "Strength in Numbers." The theme is supported with headlines (such as "Two Minute Warning" and "Prevention is Primary") and numerical wordplay (transposing zeroes for the letter O, the number one for the letter I, etc.). The designer selected duotones for the photos to enhance their irregular quality and chose a black-and-orange color theme to keep with the club's official colors. The report is an attractive, readable look at a thriving not-for-profit that doubles as its primary marketing, communications and fund-raising tool.

Cost-Saving Techniques The designer put considerable effort into convincing his German suppliers to contribute their services and products or seek only at-cost remuneration for them. He even incorporated scrap double-loop binding, left over from a printer's annual calendar production run, into the annual report to save money on that normally expensive design element.

Special Production Technique Every other page of the book is a half-sheet, measuring 4¼" x 11" (10.8cm x 27.9cm), which carries features about Boys & Girls Club members and how the club has helped them achieve success in school and life. The final half-page carries a list of the club's boards, officers and staff.

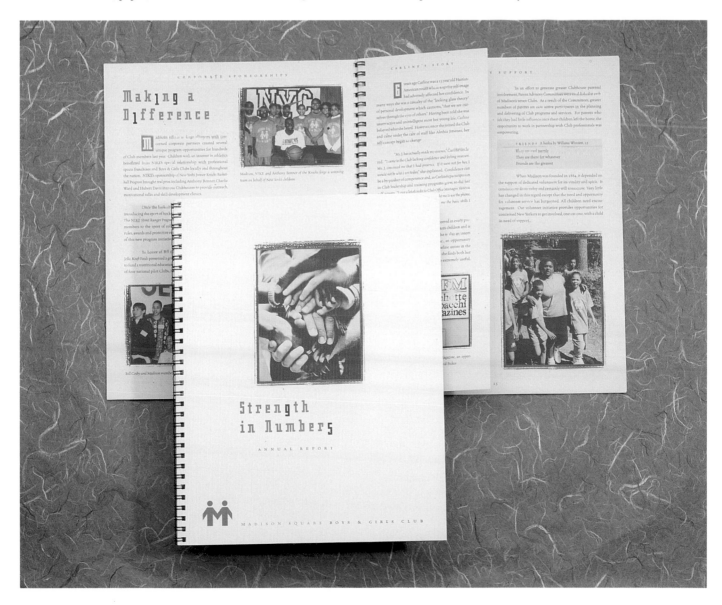

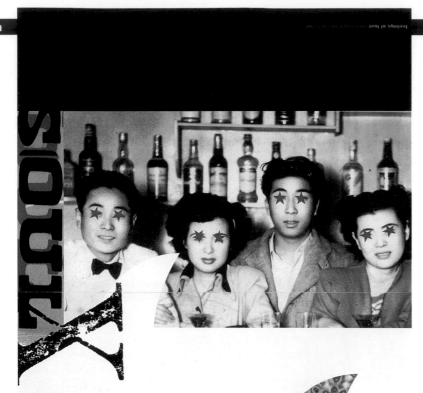

Commemorative Columbus Society of Communicating Arts 1995 Catalog

Art Director/Studio Kirk Richard Smith/Firehouse 101 Art & Design
Designers Kirk Richard Smith, Brad Egnor
Illustrator Michiko Stehrenberger
Digital Collage Keith Novicki, Marcelle Knittel
Photographers Stephen Webster, Will Shively, Chas Krider
Found Photography Collection of Kirk Richard Smith
Copywriter George Felton
Prepress SEPS
Printing Watkins Printing Co.
Client/Service Columbus Society of Communicating Arts/Professional association
Paper Sterling Paper and Repap Mills
Colors Four-color process, plus silver and a varnish
Typefaces Base, Snell Roundhand, Times Roman, Helvetica Neue
Printing Sheetfed, six-color press
Cost Color output = $200; catalog bags = $250; all other work or products donated.

Concept Following a year of turmoil—the loss of a president and officers and the cessation of regular meetings—the Columbus Society of Communicating Arts put out a winners' catalog of near-historic proportions. It was oversized in both dimension (a six-color, 9¾" x 13¼" [24.8cm x 33.7cm] book with sixty-four pages) and in reach. The opening pages offered a "stream of consciousness" attitude, with images of a tattooed man, a Korean city, a hairpin, motel signage, Lucky Charms cereal and pornographic photographs—to name a few. In producing this twenty-sixth annual catalog, the designers sought to create more of a coffee-table book than a winners' list to be filed away on a shelf.

Out of necessity, of course, the winners are duly noted, complete with photographs (typically three to a page) of each winning entry and explanatory text.
Cost-Saving Technique An extensive list of suppliers worked free-of-charge to help revive the CSCA.
Special Visual Effects The eclectic mix of photographs and other paraphernalia (i.e., hairpins, Lucky Charms) make every page of the opening sequence a disorienting surprise. Creative use of type—with each line overlapping the next and diminishing in size moving down the page—also leaves the reader disconcerted.
Special Production Technique Most of the pages were prepared in Quark and Photoshop.

DOG & PONY FARM

Dog & Pony Farm Logo

Art Director/Studio Brandon Scharr/BlackBird Creative
Designer Brandon Scharr
Design Director Patrick Short
Illustrator Brandon Scharr
Client/Service Robin and Jim Konieczny/Boarding farm for horses
Color Black
Typeface Memphis
Cost Creative time was donated.

Concept While spending the day at the boarding farm of Robin and Jim Konieczny, the designers were amused by the playfulness of their dog, Max, and horse, Pistol. The animals chased each other endlessly through the pastures to the delight of their onlookers. The designers thus named the farm "Dog & Pony Farm." They decided the most appropriate way to illustrate the spirit of the romping critters was with a weather vane—devices that have become, in recent years, artistic expressions unique to the farms they guard. With the logo of the weather vane, the designers depict the personality of the farm with help from its two most amusing entertainers, as they seek to capture the attention of prospective boarders.
Cost-Saving Technique All design work was gratis.
Special Visual Effect The black-and-white design evokes the clean, spartan feel of an actual weather vane.

Pet Walk-A-Thon Logo

Art Director/Agency Brett Stiles/GSD&M Advertising
Designer Brett Stiles
Client/Service Humane Society of Austin/Pet protection agency
Color Black
Cost Donated

Concept Imagine what might happen when dogs and cats and their owners come together for an event like, say, an organized walk. A man might walk a dog while the dog chases a cat and they all might end up running in circles. This whimsical logo for the Pet Walk-a-Thon in Austin, Texas, perfectly captures the comedy that might ensue. The designer kept the logo clean and simple to give it multiple uses in publicizing the walk and raising money to stop the overpopulation of pets.
Cost-Saving Techniques With clean lines and just one color, the logo was easy and inexpensive to reproduce.

AIGA "Judge for Yourself" Poster

Art Director/Studio Leslie Phinney/Phinney/Bischoff Design House
Designer Juli Saeger
Copywriter John Koval
Client/Service AIGA Seattle/ Graphic arts organization
Paper Columns Classic Crest
Colors Four PMS
Typefaces Fragile, M-Script Bold, Courier, Orator
Printing Offset
Cost All services were donated, including printing.

Concept In most design shows, the judges rule. Designers enter what they consider to be top-notch; judges pick what they like best. In this show, open to members of three graphic arts organizations, judges had no say. In fact, there were no judges. To communicate that fact, the designers said simply: "Forget the Judges." The combination entry form/poster/direct-mail piece, a four-panel sheet measuring 11¼" x 23⅜" (28.6cm x 59.4cm), shows a group of intimidating figures with censor bars over their mouths, noting that all entries would be included in a nonpartisan, nonjuried, no-nonsense CD-ROM to showcase the work

of designers in the northwestern United States. The CD-ROM, titled "Working on the Edge," was then distributed to all attendees of an AIGA National Design Conference.
Cost-Saving Techniques The project was designed to incorporate three pieces in one: entry form, poster and direct mailer. All design and printing work was completed pro bono. The designers used old photos instead of purchasing illustration or photography.
Special Visual Effects The designers reinforced the concept by using fractured type and by distorting the judges' faces by use of halftone dots, stretching and floating.
Special Production Technique The designers manipulated the halftones and type to create an imposing visual effect.

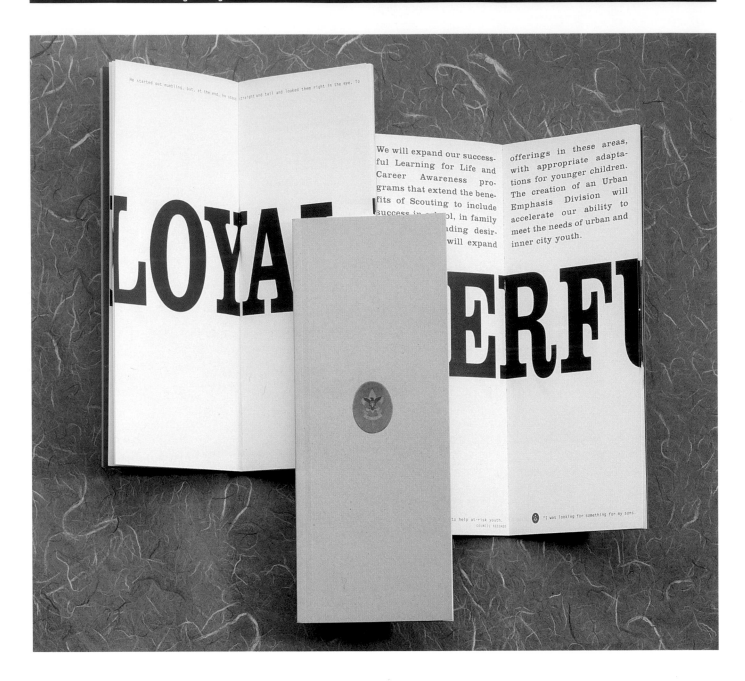

Boys Scouts of America Plan Booklet

Art Director/Studio John Van Dyke/Van Dyke Company
Designer John Van Dyke
Copywriter Tom McCarthy
Client/Service Boy Scouts of America, Chief Seattle Council/Service club
Paper Simpson Coronado, French Dur-O-Tone
Colors Four-color process for cover, two PMS inside
Typefaces Claredon, Letter Gothic Bold
Printing Offset
Cost Donated

Concept Trustworthy, loyal, helpful, friendly. The designers of this project for the Chief Seattle Council of the Boy Scouts spelled out words associated with scouting in dramatic, 3-inch (7.6cm) letters on pages just 4³⁄₁₆-inches (10.6cm) wide. Centered on otherwise bare white sheets, the letters continue through the forty-four-page, 11-inch (27.9cm) high book, spelling out more of the scouting credo: Courteous, kind, obedient . . . Cheerful, thrifty,

brave . . . Clean. Reverent. Amid the running list is the text of the fund-raising/awareness project, outlining a long-range plan to take the council to the year 2016 and its one hundredth anniversary. Running along the top and bottom margins of the pages are quotes about the value of scouting from supporters—instructors, board members, parents and others. The combination of elements, presented with no illustration, photographs or graphic enhancement, pulls the

reader quickly to the core message: the value of scouting.
Cost-Saving Technique Limited design values held down costs in this pro bono project.
Special Visual Effect Oversized type, with words starting on one page and continuing on the next, result in a dramatic "page-turner" of a plan booklet.
Special Production Technique Boy Scout logo is embossed on front cover.

Cooper-Hewitt Design Museum Fund-Raising Auction Invitation

Art Director/Studio Janine James/The Moderns
Designer Kevin Szell
Client/Service Cooper-Hewitt National Design Museum/ Design museum
Paper Cranes Old Money Greenback, 90#, for cover and response card. Vellum for committee insert sheet.
Colors Black and a metallic
Typefaces New Baskerville, Futura
Printing Offset
Cost Digital services, messengers and miscellaneous costs = $680 for 15,000 pieces; designer and printer donated their services.

Concept Black-tie events deserve black-tie design treatment. That's what the Cooper-Hewitt National Design Museum got with this invitation to its Third Annual Gala Auction.

The five-item piece actually went to potential guests for a silent tabletop auction, thus the muted images of a table (on the cover) and table setting (inside). The invitation is simple yet sophisticated, spelling out the details of the fund-raiser in clear language with clean graphics yet adding a note of intrigue with the word "alchemy," the definition of which is printed and embossed on the cover. The word—defined as "a method or power of transmutation; especially the seemingly miraculous change of one thing into something better"—hints at both the event and the benefactor of the event: An auction, after all, allows the exchange of cash for "something better," while the work of designers often involves transmutation. The 6⁷⁄₁₆" x 5" (16.4cm x 12.7cm) invitation comes with an envelope, a

similarly sized insert listing committee members and a 5½" x 4" (14.0cm x 10.2cm) ticket order form and matching envelope.
Cost-Saving Technique Limited use of color and artwork held down design and production time.
Special Production Technique Part of the cover type—the definition of the word alchemy—is embossed, created by using a knockout of the offset with a tight register blind emboss.

IDEA Brochure

Art Directors/Studio Judy Kirpich, Richard Hamilton, Claire Wolfman/Grafik Communications, Ltd.
Designers Judy Kirpich, Richard Hamilton, Claire Wolfman
Illustrators Jeff Brice, John Hersey, John Craig, Wayne Vincent, Michael Sheau, Ned Drew
Copywriting/Marketing Supervision Andrea Pellegrino/ Marketing General Inc.
Printer Deborah Dean/CK Litho
Client/Service International Design by Electronics Association (IDEA)/ Professional association
Paper Glossy card stock and flat-white stock
Colors Four-color process
Typefaces Bodoni, OCRB, Courier
Printing Offset

Concept Playing off the acronym IDEA and the idea for a new professional association, the designers used the word idea to explain and solicit members for IDEA—the International Design by Electronics Association. Appropriately, considering that the association was created for designers who use computers in their work, the illustrations used in the twelve-page, 4⅜" x 6" (11.1cm x 15.2cm) booklet are computer-generated. The cover has an image of the seas and the heavens. Inside are images that integrate idea-like icons (eyeballs, question marks, people at computers, etc.) with idea statements (What is the idea? What a great idea! A one-of-a-kind idea!) Other pages are given over to descriptions of the new group, its benefits and a sign-up form with envelope.

Cost-Saving Technique Convincing the client to combine a brochure and a membership form, rather than designing them as separate pieces, saved considerable funds.

Special Visual Effect The designer used FreeHand, Illustrator, Photoshop and Quark to create and combine artwork.

Special Production Technique The designer worked closely with the U.S. Postal Service and printer to design a perforated response card/membership form.

savings...as much as **40% SAVINGS** on all design–related hardware and software through Computerland, plus savings on DesignSoft software, plus an exclusive, no money down **APPLE LEASING PROGRAM** for IDEA members only. **LOCAL RESOURCES/NETWORKING**... at your local chapter meetings. You'll meet your local design colleagues. Learn from their expertise–or **SHARE** your own.

applications. Tap into a **VITAL NETWORK** of knowledge and contacts. **TRAINING** ... at your local chapter meetings and seminars. Plus, the three-day, hands-on **CREATIVE CONFERENCE** cosponsored with HOW magazine combining design business techniques with the latest in computer design. Plus, significant **DISCOUNTS** on courses at the Center for Creative Imaging and from Quantel.

International Design by Electronics Association

IDEA MEMBERSHIP IS OPEN TO PROFESSIONALS WITH A COMMITMENT TO ADVANCING THE STATE OF DESIGN THROUGH THE USE OF NEW TECHNOLOGY.

IF YOU BELIEVE IN THE POWER OF DESIGN AND THE POTENTIAL OF COMPUTERS IN DESIGN, YOU BELONG IN IDEA.

JOIN US TODAY IN CREATING THE FUTURE.

2200 Wilson Boulevard
Suite 102-153
Arlington,
Virginia 22201
1-800-466-1163

PEN Canada Poster

Art Director/Studio Frank Viva/Viva Dolan Communication & Design
Designer Frank Viva
Illustrator Frank Viva
Photographer Hill Peppard
Client/Service PEN Canada/ Nonprofit agency
Paper Conqueror Bright White Woven
Colors Four-color process
Typeface Meta
Printing Lithography
Cost Design and production donated.

Concept This project for PEN Canada cuts right to the heart of the issue: Imprisoned or persecuted writers are not free to express their ideas. The designers of this poster used pages from a novel by Aleksandr Solzhenitsyn, the long-persecuted Russian writer, as the background. In the illustration, drawn directly atop the pages, ideas unfold in the character's mind but cannot escape from his gagged mouth. The 24" x 34" (61.0cm x 86.4cm) poster was distributed to PEN clients to increase awareness of the group and its efforts.
Cost-Saving Technique All services were donated.
Special Visual Effect The photograph of the roll of information in the figure's head was combined with the hand-drawn figure in Adobe Photoshop.

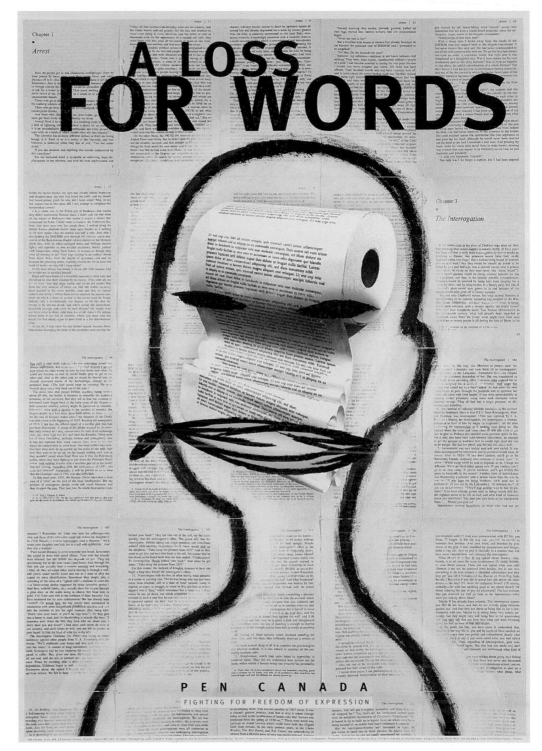

Big Brothers/Big Sisters Benefit Poster

Art Director/Studio Madeleine Corson/Madeleine Corson Design
Designer Madeleine Corson
Photographer Thomas Heinser
Color Separator Repro-Media
Client/Service Advertising Photographers of America/ Professional association
Colors Four-color process
Typeface Courier
Printing Lithography, sheetfed
Cost Design, printing and color separating donated.

Concept A child in adult shoes can mean many things. Playtime. Imitating Daddy. Irritating Mommy. In this 20"

x 16" (50.8cm x 40.6cm) piece created for a benefit auction and raffle for the Big Brothers/Big Sisters in the San Francisco area, the small feet and skinny legs in the men's dress shoes provide the perfect metaphor for the program and its participants. The poster was hung in stores, cafés and restaurants to create more awareness for the Big Brothers/Big Sisters program and to generate interest in the fund-raising event. The event raised money by auctioning off work donated by members of the Advertising Photographers of America.

Cost-Saving Technique
The designer, photographer, printer and color separator all donated their services.
Special Visual Effect The photograph was shot with an 8x10 camera.

Homeless Advocacy Benefit Poster

Art Director/Studio Madeleine Corson/Madeleine Corson Design
Designer Madeleine Corson
Photographer Thomas Heinser
Color Separator Repro-Media
Client/Service Advertising Photographers of America/Professional association
Colors Four-color process
Typeface Letter Gothic
Printing Lithography, sheetfed
Cost Design, photography, printing and color separating donated.

Concept The image of a man with a scraggly beard and dirty fingernails holding a cardboard sign is one instantly familiar to most viewers today. The man is homeless. The designer of this 20" x 16" (50.8cm x 40.6cm) poster chose that straight-forward yet haunting image to announce an auction and raffle sponsored by the Advertising Photographers of America to benefit the Homeless Advocacy Project in the San Francisco area. As with the Big Brothers/Big Sisters project by the same team, the posters were hung in stores, cafes and restaurants to create awareness of the pro-gram, to aid the homeless and to generate interest in attending the fund-raising event. The event raised money by auctioning off photos donated by members of the Advertising Photographers of America.

Cost-Saving Technique All services were donated.
Special Visual Effect The photographer shot the subject with an 8x10 camera.

Boy Scouts of America 1995 Annual Report

Art Director/Studio John Brady/John Brady Design Consultants, Inc.
Designers John Brady, Christine McIntyre
Photographer John Wee
Printer Reed & Witting Company
Production Julie Poskie
Client/Service Greater Pittsburgh Council of Boys Scouts of America/Scouting organization
Paper Benefit Natural Rye, Kromkote
Colors Four-color process
Typefaces Adobe Garamond, Helvetica
Printing Offset
Cost 3,200 copies cost $5.80 each, all of which was donated.

Concept Long before a discussion of values became fashionable, the Boy Scouts were preaching the message to members. In fact, when the scouting organization was created in 1911, the very first handbook outlined the values that scouts should take to heart. In 1995, the Greater Pittsburgh Council of Boy Scouts highlighted values once again in its annual report. Working with that theme, the report designers located all ten of the scouts' handbooks, photographed and interspersed them throughout the report. Each was photographed with a Kodak DCS 420 Digital Camera, which allowed the designers to eliminate the use of photo chemicals. The forty-six-page, 5" x 6" (12.7cm x 15.2cm) book includes extensive text about the Greater Pittsburgh Council's growth, progress, finances and programs. It also includes a collection of twelve black-and-white snapshots of varying sizes from scouting events, each bound individually and presented as something of a photo album of the year just past.

Cost-Saving Techniques The use of digital photography and hand-stitched binding reduced overall costs.

Special Visual Effects The designers imported each digital photo of the scouting manuals into Adobe Photoshop and created colored "glows" around the books. Images were also adjusted at that phase to compensate for the color of the paper stock.

Special Production Technique The designers bound each of the 3,200 annual reports by hand, using a traditional blanket stitch. They inserted the binding into standard holes used in wire binding. Book pages were rounded with a ⅜-inch (1.0cm) rounding die after collating.

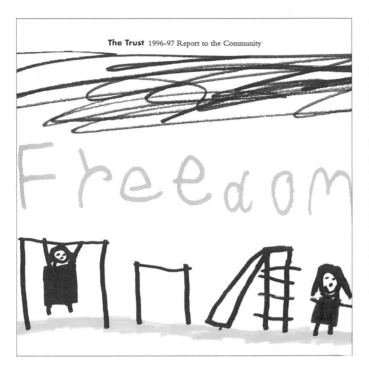

The Trust Annual Report

Art Director/Studio Robert Louey/Louey/Rubino Design Group Inc.
Designer Tammy Kim
Illustrators Chelsea Herbert, Julie Moench, Keri Mudrick
Printer House of Graphics
Copywriting WWW.COM/ Gregory A. Waskul
Client/Service The Trust/ Nonprofit agency
Paper Georgia-Pacific Felt Weave
Colors Four-color process
Typefaces Futura, Bembo
Printing Lithography
Cost Pro bono

Concept The Trust, which provides playgrounds, field trips and other extracurricular activities to Arizona public school children, wanted to create an annual report to communicate the accomplishments of its first decade to its key publics. With very limited funds, the designer and writer of this project stepped forward, on a pro bono basis, and put together a compelling, highly readable twenty-four-page Report to the Community in just seventy-five days. They selected the theme of "freedom," keying The Trust's ability to bring freedom to the state's school districts and school children through its work. They highlighted the theme with artwork contributed by school kids. The Report to the Community was such a hit with The Trust's board and the community at large that the board increased the print run on the 8½" x 8½" (21.6cm x 21.6cm) books from one thousand to five thousand and scrapped plans to produce a separate capabilities piece in favor of using the annual report. In addition, the artwork created for the report was saved for a traveling exhibit in Arizona.
Cost-Saving Technique All project management, design work and writing were completed pro bono.
Special Visual Effects The designer and writer, as co-project managers, solicited artwork from school children across the state. They replicated colors in the artwork throughout the annual report for type and backgrounds.

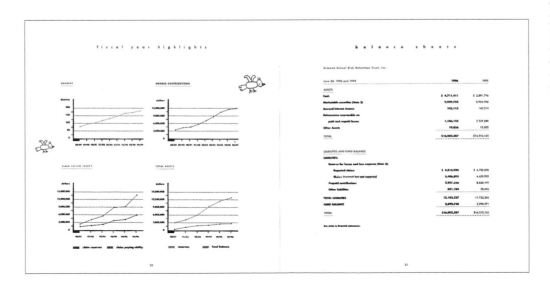

Austin Theatre for Youth Stationery

Art Director/Studio Brett Stiles/GSD&M Advertising
Designer Brett Stiles
Client/Service Austin Theatre for Youth/Theater
Paper French Speckletone True White Text
Colors Two PMS
Typefaces Hand-lettering, Just Left Hand
Printing Offset
Cost Printing, paper, films = $755; design donated.

Concept With this project for an Austin theater, the designer aimed to create an identity that projected a fun but sophisticated attitude. The pieces also needed to be flexible enough to appeal to a broad age group. The type, colors and off-kilter placement of the logo—as well as the name of the theater itself—work together to communicate the youthful orientation of the group without alienating the adult audience.
Cost-Saving Techniques The designer limited the project to two colors and avoided bleeds to hold down costs.

512-459-7144

5555 N. LaMaR · SuitE C-125 · AuStiN, TX 78751

MISCELLANEOUS PIECES

The Extended Moment

Art Director/Studio Daniel R. Smith/Command Z
Designer Daniel R. Smith
Illustrator Daniel R. Smith, Roderick Romero
Photographer Roderick Romero
Author Roderick Romero
Editing Kathy Mar
Client/Service Roderick Romero/Self-published book
Paper Cover: 80# Speckletone Cover Black; Interior: 80# Repap Matte Book
Colors Silver PMS, black
Typeface Bodoni, Orator
Printing Offset
Cost Printing, paper and film for 1,000 = $7,800.

Concept Roderick Romero, singer and songwriter for the band Sky Cries Mary, was inter-ested in publishing a selection of his writing, including one longer piece called "The Extended Moment." Some of the pieces are poems, some recollections of dreams, some musings on current events, some fragmented accounts of a band's life on the road. The designer pulled the pieces together using mostly computer collage work, along with headlines pulled from the pieces, scanned paper collages, photos and creative placement of white space.

The fifty-seven-page book, measuring 8½" x 10" (21.6cm x 25.4cm), is obviously aimed at the band's fans, being distributed through the Sky Cries Mary Fan Club.

Cost-Saving Technique The minimal use of color held down production costs.
Special Visual Effects Extensive use of collage art reflect the somewhat frenzied tone of the writing.
Special Production Technique Two sets of film were run to ensure precise lineup of spreads across the book's gutter.

Dolores Dolores Bar Menu

Art Director/Studio Vincente Lo Schiavo/Lo Schiavo Design Group
Designers Dino Vettorello Filho, Gaston Lefebvre
Client/Service Dolores Dolores Bar/Bar
Paper Gilbert, Esse
Color Black
Typeface Casa Blanca Antique
Printing Inkjet printer, HP 5000
Cost $7 each, old book included

Concept To enhance the image of this Brazilian bar as a cabaret, the designers of the bar's drink menu started with a selection of antique 5" x 7" (12.7cm x 17.8cm) books. First, they glued the bar's logo over each book's cover title. Inside, they added pages listing available drinks (and a few food items) to the center of the book. They then marked the menu pages by gluing a velvet ribbon into the binding. Otherwise, the book is, well, a book. The example shown is an Italian play, copyright 1928, called *La Nuova Colonia*. Only when the reader gets to page 150 does he realize that the list of "bebidas" —including a tequila and grenadine concoction called Dolores Dolores—does not advance the play's plot.
Cost-Saving Techniques The use of old books eliminated the need for menu covers. In-house production of type, on an inkjet printer, reduced printing costs.
Special Visual Effect Antique books provide an unusual presentation for a menu.

Pesto Cookbook

Art Director/Studio Marianne Mitten/Mitten Design
Designer Marianne Mitten
Illustrator Steve Salerno
Client/Service Chronicle Books/Book publisher
Paper 127 GSM Matte Art, 150 GSM Matte Cover
Colors Four-color process
Typefaces Copperplate Gothic 29 BC, 32 BC, 33 BC; Janson Roman, Janson Italic, Janson Bold; Zapf Dingbats; New

Century Schoolbook; hand-lettering
Printing Offset Lithography
Cost $3 each

Concept The Chronicle Books cookbook series that includes Pesto is called the "artful kitchen collection" for a reason. The books are illustrated with colorful, original artwork. For Pesto, the designer and client turned to an illustrator whose

style and color palette reflect the vibrant colors and flavors of pesto. The twenty-five illustrations in the 6¾" x 6¾" (17.2cm x 17.2cm), seventy-two-page hardbound book depict herbs, olives, peppers, garlic and a variety of kitchen tools in rich blues, golds, greens, reds and browns. Full-page illustrations, with original calligraphy, mark the beginning of each section of the book (Pestos, Appetizers,

Soups & Salads, Entrees, etc.) Half-page illustrations are sprinkled throughout the pages.
Special Visual Effect Using the colors found in many of the ingredients from the cookbook helps unite the subject and design.

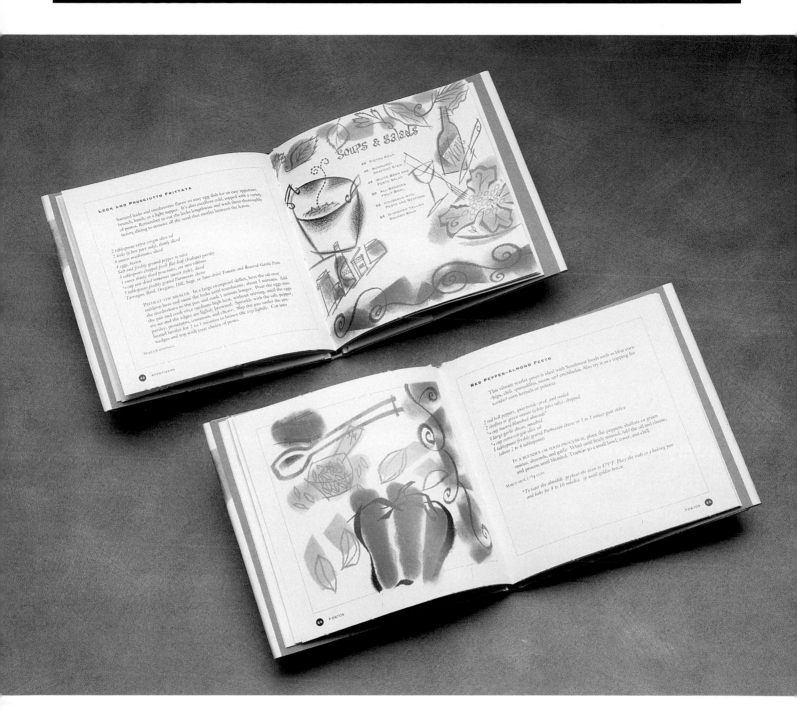

The Daruma Story

Art Director/Studio Debbie Kong/Debbie Kong Design
Designer Debbie Kong
Illustrator Debbie Kong
Copywriter Cindy Sterns
Programmer Pat McClellan
Client/Service Debbie Kong Design/Graphic designer
Paper Creamtext for cover and inserts, French Speckletone for text sheet
Colors Four-color process
Typefaces Palatino, Bodoni
Printing Inkjet printing on Epson Stylus Pro
Cost Computer disk = $.13 each; paper = $15; calligraphy = $50; mailing boxes = $20; ink = $50; postage = $.55 each. Hand-delivered copies = $1.28; mailed copies = $2.03.

Concept The designer of this self-promotion piece turned to Japanese mythology and the story of the Daruma to illustrate her multimedia capabilities. The Daruma, the story goes, is a philosopher who meditated so long and hard that his arms and legs fell off. What is left is an odd-looking head, in bright gold and red, with no eyes. According to the myth, the owner of the Daruma doll should draw in the left eye to make a wish come true and the right one in gratitude for receiving the wish. The designer related the Daruma story on disks sent to clients and potential clients. Each disk carries a label bearing a Daruma illustration, which is repeated on a disk wrapper, table tent, blank sheet (to protect the disk from the other elements) and explanatory insert. Each of the pieces, with the exception of the insert, measures 3½" x 3¾" (8.9cm x 9.5cm), the same as the disk. The explanatory insert is 5⁵⁄₁₆" x 8½" (13.6cm x 21.6cm). Within twenty-four hours of sending out the piece across Chicago, the designer discovered that the Daruma story had traveled to Texas. She subsequently received e-mail requests for copies from across the country.

Cost-Saving Technique Printing costs were reduced by using an inkjet printer.
Special Visual Effects Most of the visual effects on the disk were created in Adobe Illustrator, Adobe Photoshop and Macromedia Director.
Special Production Technique The designer used Photocaster, in conjunction with Macromedia Director, to import layers for the disk.

[T-26] Print Ad

Art Director/Studio Carlos Segura/SEGURA INC.
Designer Carlos Segura
Client/Service [T-26]/Font foundry
Color Black
Typeface Tema Cantante
Cost $35

Concept The designer created this print ad for a company he owns to promote a new relationship between the company, a font maker called [T-26], and a distributor called Fonts in a Flash. The piece is simple, centering the [T-26] name in oval-shaped text box and topping the box with dingbats called Deadbug Font. The ad, which appeared in *Creativity* magazine, works to both promote [T-26] and publicize its newest distributor.

Cost-Saving Techniques The designer used just one color for the ad and did all the work in-house. The distributor paid for the ad space.

Oaxaca Restaurant Menu

Art Director/Studio Sonia Greteman/Greteman Group
Designers Jo Quillin, Sonia Greteman, Chris Parks
Photographer Ron Berg
Client/Service Oaxaca Grill/Restaurant
Paper Kimdura for cover, Speckletone for insert
Colors Black, metallic copper
Typeface Copperplate
Printing Offset
Cost $5 each

Concept As the traditions of Oaxaca set the tone for the Wichita, Kansas, restaurant of the same name, so, too, did they dictate the design standards for the restaurant's menu. Oaxaca, one of the oldest cities in Mexico, is known for its pottery, sculpture, jewelry, textiles—and food-filled fests. The designers of the Oaxaca Grill's menu hint at many of those attributes with their design. The front of the 8⁵⁄₁₆" x 14" (13.6cm x 35.6cm) menu cover includes Zapotec Indian symbols, copper imprinting and textural elements such as embossing and weathered metal edging to create a "MesoAmerican" feel. The back of the menu cover carries the Oaxaca story. Inside the cover, some of the same graphic devices are repeated on the four menu pages, especially to highlight different food categories.

Cost-Saving Technique The designers selected washable paper for the menu cover, to allow the restaurant to keep them clean. They also used narrow elastic bands to bind the menu pages to the cover, allowing for easy changing.

Special Visual Effect The embossed logo has the appearance of a brand.

Special Production Technique The menu cover is bound with a rusted metal strip studded with three rivets.

After Hours Creative
Help Wanted Ad

Art Director/Studio Russ
Haan/After Hours Creative
Designer After Hours Creative
Client/Service After Hours
Creative/Design studio
Color Black
Typeface Flexure, distorted in
Adobe Photoshop
Printing Offset
Cost $100

Concept Talk about prescreen-
ing applicants. This creative
studio, with offices in Atlanta
and Phoenix, laid all its cards
on the table for a newspaper ad
it created to recruit new staffers.
The agency decided to take
advantage of unusual conditions
or events that might seem nega-
tive and recast them in a pro-
vocative way to underscore its
reputation. Applicants uncom-
fortable with homosexuality or
pro bono work were, therefore,
forewarned of the agency's
position on those issues. The ad
was created literally in one day,
when the targeted publication
offered ad space at half-price
after another ad fell through.
Cost-Saving Technique The
type-only treatment of the piece
and use of one color held costs
down.
Special Visual Effect Type was
distorted in Adobe Photoshop.

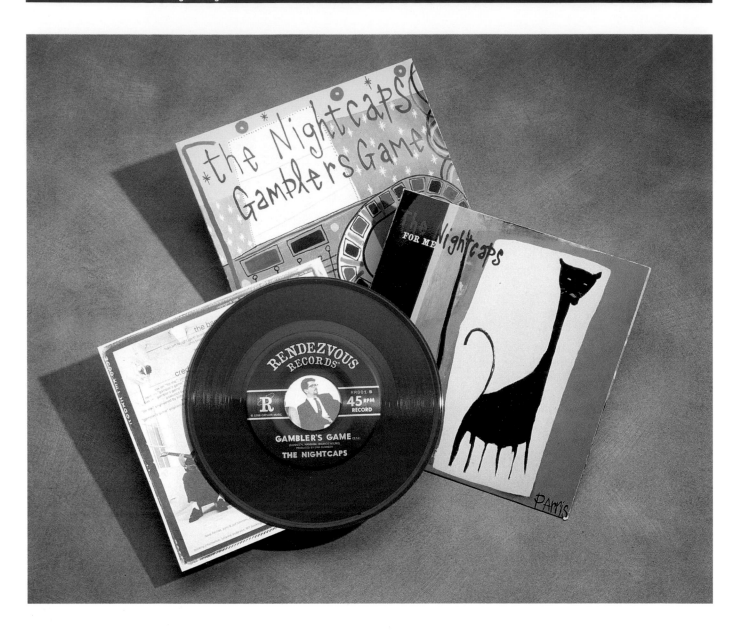

The Nightcaps
Single Cover

Art Director/Studio Daniel R. Smith/Command Z
Designer Daniel R. Smith
Illustrator Parris Broderick
Photographer Mark Van S.
Client/Service The Nightcaps/Band
Paper High-gloss card stock
Colors Four-color process for cover, black for insert, silver for record label
Typefaces Hand-lettering, found type, Franklin Gothic, Univers
Printing Offset
Cost Package single pressing, print cover and record label = $1,600; insert printing = $165;

photography and scans = $200. Design, art and photo work were donated for in-kind considerations. Total: $2,000 for 1,000 record singles.

Concept Everything about this project is retro. The client is a band that plays lounge music. The project they offered was a 45-RPM vinyl record design. So naturally, the designer turned to motifs of the 1940s and 1950s to complete the job. For the record's 7⅛-inch (18.1cm) square jacket, he used two pop art/modern art paintings, one created for the project (the

Gambler's Game side) and one completed earlier by the painter (the cat). The record itself is a cherry-red vinyl with label type taken from newsprint magazines of the 1950s to give it a slightly vintage look. The 6½-inch (16.5cm) square insert is a photo of the band—the guys in dark suits with skinny ties, white shirts and white socks; the female singer in a little black dress and pearls. The result: an album that you'd expect to be hidden away in the back of your parent's hi-fi cabinet.

Cost-Saving Techniques The painter donated the cover paint-

ings in exchange for product. The photographer donated the band photo in exchange for a band performance at a party he threw. The designer worked for a few drinks and a handshake.

Special Visual Effect Use of red vinyl for the record brings the retro look to completion.

Special Production Technique The designer had little control over production because the film was sent to a company that presses records and prints record jackets as a package deal. The arrangement did not allow for press checks.

Boxart Inc.
Holiday Promotion

Studio Zubi Design
Designer Kristen Balouch
Copywriters Dennis Fisher,
Shannon Stolfo
Client/Service Boxart Inc./Fine
art crating and packaging
Paper Strathmore Gray, Wax
Brown
Colors One PMS for the box,
two PMS for the logo label, two
PMS for the paper wraps, and
three PMS for each of the three
T-shirts
Typefaces Gill Sans, Albertus
MT, Bodoni, Castellar MT,
Futura, Kathlita, Maximus,
Minion
Printing Offset for boxes;
silkscreening for T-shirts

Concept The concept for this
holiday promotion sent to
Boxart's existing clients was to
create a package that embodied
a crated traveling exhibit. A
flip-top box covered in paper
that features bold, dynamic type
treatments of familiar shipping
terms ("Fragile," "This Way
Up," and "Keep Dry") serves as
the "crate." Each box contains
three T-shirts rolled up and
wrapped in a strip of paper. The
strip serves as handling instruc-
tions and also bears the holiday
greeting of "Peace on earth,
good will toward men." Each of
the different-colored T-shirts
features a design similar to that
on the box, plus a shipping sym-
bol that represents each of the
three shipping terms. By wear-
ing any of the T-shirts, the
clients are symbolically trans-
formed into a moving, traveling
work of art.
Cost-Saving Technique Two
different stocks of paper on the
same print run for the interior
and exterior of the box helped
cut costs.
Special Production Technique
The boxes are paper-covered
board hinged with book cloth.

"Drunken Botanists" Newspaper Ad

Art Director/Studio Peter C. Judd/mmm . . . funkalicious advertising
Photographer Elise Thompson
Copywriter Jason Siciliano
Client/Service Marilyn Brooks Clothing Boutique/Women's clothing store
Paper Lino output for newspaper reproduction
Color Black
Typefaces Pure, Stone Serif Semibold Italic, Future Light, Opti Design Medium
Cost $80

Concept The designer of this newspaper ad for a women's clothing boutique wanted to avoid the typical glamour clothing shot type of treatment. He instead focused on the store's fall line by highlighting some of the more unusually named pieces. First, he researched each name's origin. Then, he created a bizarre story around each. In this piece for a Cloché hat, the designer used a photo of a Cloché plant cover and a fanciful tale of drunken botanists. The idea: create a little mystery about what's in stock at Marilyn Brooks to lure customers into the store.
Cost-Saving Techniques The designer enlisted the help of a photographer friend to shoot the artwork; she worked for a reduced fee in exchange for the advertising experience. In addition, the designer handled all scanning and photo retouching in-house.

A GROUP OF
DRUNKEN BOTANISTS ONCE
TOYED WITH THE SAME IDEA,
BUT IT SHATTERED DURING
A PARTICULARLY ROWDY GAME
OF HOPSCOTCH.

The Cloché Plant Cover

The Cloché Hat
Part of the 1995 Fall Chocolate Culture Collection.

MARILYN BROOKS
CLOTHING BOUTIQUE

3376 SACRAMENTO STREET SAN FRANCISCO (415) 931-3376

Felissimo Restaurant Menus

Art Director/Studio Karine Mitsue Kawamura/Studio Lumen
Designers Silvio Silva Jr., Karine Mitsue Kawamura
Illustrator Silvio Silva Jr.
Client/Service Felissimo/ Restaurant
Paper Couché 300 GR
Colors Two PMS
Typeface Original, created for client
Printing Offset
Cost Cover = $.50; insert = $.08; total = $.58 per menu

Concept The designer played off this Brazilian restaurant's name and mottos to complete drink and food menus. In Portuguese, the prominent language of Brazil, the word felissimo means happiness. The São Paulo restaurant of that name tweaked the definition slightly for its mottos: "More than spirituality, Felissimo is a restaurant," reads the motto in the restaurant menu. "More than a restaurant, Felissimo is a spirituality," reads the motto for the

bar. The designer, then, incorporated those opposites into the 5⅜" x 12¾" (13.7cm x 32.4cm) menus, selecting an orange-hued cover and melon green-colored inside for the restaurant menu and swapping the colors for the bar menu. The artwork on the covers reflect the respective establishments as well: The drink menu has a waiter figure with a drink on a tray while the restaurant menu has a waiter with a covered food tray.

Cost-Saving Techniques Using the same color for both menus created a savings. Printing the insert on a laser printer also reduced costs.
Special Visual Effect The artwork on the menu covers incorporates a relief.
Special Production Technique The menu list is inserted via slotted tabs on the back of the cover.

Mixed Media Signage

Art Director/Studio Dennis Crowe/Zimmermann Crowe Design
Designer Rudiger Gotz
Fabricators Art Real, California Model, Scene2
Engraving Custom Photo-Engraving
Colors Wood grain, metal
Typeface Original design
Printing Silkscreen, photo-engraving
Cost $950

Concept Hair and skincare consultants John and Paul Sasso, owners of a shop called Mixed Media, wanted an exterior sign that would reflect their salon's collection of fine art and custom-designed furniture. The designer selected a look that stems from Mixed Media's logo and name. The resulting sign combines three elements—a steel-toned section that carries the shop's name, a wood-grain section and a portion marked with the initial "M." The sign both communicates the shop's image and fits well in the funky Mission District San Francisco neighborhood where it operates.
Cost-Saving Technique The designers used three different fabricators for the sign, cutting the original cost estimate for the job from a single fabricator in half.
Special Visual Effect Combining three different materials reflects the client's name and image.

Businesses for Clean Water 1997 Calendar

Art Director/Studio Janet DeDonato/TeamDesign Inc.
Designer Jeff Barlow
Client/Service King County Surface Water Management Division/Government agency
Paper Simpson Evergreen Birch, 70# text
Colors Five PMS colors
Typeface Helvetica family
Printing Offset
Cost $3.40 per piece

Concept Twelve months gave the designers of this calendar twelve chances to bring home their client's message: Don't dump polluted water into storm drains. A project of the Business for Clean Water arm of a Seattle-area water management department, the calendar offers a tip-a-month to businesses that use water and/or water-related chemicals. Among them: Clean up spills immediately, minimize the use of lawn and garden chemicals and label storm drains. The 11" x 9" (27.9cm x 22.9cm) piece follows basic calendar design, opening along a stapled horizontal fold so that the tip-a-month pages sit above the pages with the months and dates. The calendar also includes an opening page telling readers why not to pollute storm drains and a back page that provides space for a mailing label along with a list of members of Businesses for Clean Water.

Cost-Saving Techniques The designers used low-resolution photography to avoid scanning and separation costs. They also printed the piece on a two-color press, switching yellow with green on opposite sides of the forms. That gave them five colors without an additional press run (black, blue, red and yellow on one side; black, blue, red and green on the other side).

Special Visual Effect A logo for Businesses for Clean Water—a splashing fish circling the word "for"—appears on every spread to unify the piece.

Ghostlikesun CD Cover and Inserts

Art Director John Havel
Designer John Havel
Photographer Bruce Racine
Client/Service Ghostlikesun/Band
Paper Sheer Print, Extra White, Basis 39
Colors Black, PMS 8582 metallic
Typefaces Avenir, Robust
Printing Offset
Cost Printing = $920; films = $56; total = $.99 each.

Concept Think ghost. Think light. Now think about how to present those concepts in a graphic way. That's how the designer approached the task of designing the cover and inserts for a CD for San Francisco-based band Ghostlikesun. He chose vellum to create a transparent and elusive quality, using the paper for all five 4¾" x 4¾" (12.1cm x 12.1cm) pieces in the CD. The first sheet is the image of a veiled woman holding something round in her outstretched hands. The next two sheets list the songs and their lyrics. A fourth sheet is a woman, in three-quarter profile, shown as a negative. The final sheet, inserted in the back of the CD case, is a list of credits and playing times on the CD's cuts.

Cost-Saving Techniques All the pieces were printed on 11" x 17" (27.9cm x 43.2cm) sheets and trimmed, eliminating the need for folding, scoring or binding. The final insert created both the back cover and the spine of the CD.

Special Visual Effect The use of vellum played off the band's name and the title of the CD, "Loud as Light."

Loony Letters Block Set

Art Director/Studio Kristen Balouch/Zubi Design
Designer Kristen Balouch
Copywriter Shannon Stolfo
Client/Service Zubi Design/ Design firm
Paper Hopper Nekoosa 80# Ivory Vellum
Colors Twelve PMS colors for blocks, two PMS colors for sleeve, one PMS for box
Typefaces Hand-lettering for blocks. Hand-lettering, Gill Sans and Futura for packaging.
Printing Offset for packaging. Silkscreen for blocks.
Cost About $15 per set

Concept Wooden alphabet blocks have been a staple in the toy boxes of America for decades. Building on their sim- ple design, the designers of Loony Letters created a ten- block set that would look as good in corporate cubicles as toddlers' bedrooms. Like tradi- tional blocks, each 1¾-inch (4.5cm) Loony Letter square has a single letter on each of its six faces. Unlike traditional block letters, though, these let- ters come in vibrant colors (lime green, pastel purple, fire red, among them) and quirky shapes (a Y, for one example, looks like a bull's head with horns). The block's box—really a 4½" x 9¼" (11.4cm x 23.5cm) open- face box bottom—is made of corrugated brown cardboard and marked with maroon stripes and the Loony Letters logo. A paper sleeve slips over the box to hold in the blocks. It also carries the logo, along with several sugges- tions for what to do with the blocks. Among them: ". . . Stack. Build. Knock. Roll and spell. Create. Imagine . . . "

Cost-Saving Techniques The designer saved money on the paper wrap by overlapping the screens of two PMS colors to give the illusion of a third color. By minimizing the block colors to twelve selections, all the blocks were printed at the same time.

Special Visual Effects The blocks are slightly larger than other building blocks; that fea- ture combined with their offbeat lettering and colors make them stand out on retailers' shelves.

Directory of Design Firms

AERIAL
58 Federal St.
San Francisco, CA 94107

After Hours Creative
1201 E. Jefferson, B100
Phoenix, AZ 85034

aire design company
300 W. Paseo Redondo
Tucson, AZ 85701

Andrew Lewis Design
7465 Mulberry Place, Suite 20
Burnaby, British Columbia, Canada V3N
5A1

BlackBird Creative
100 N. Tryon St., Suite 2800
Charlotte, NC 28202

Blind Co., Ltd.
Samsen Nai Village
100/41 Samsen Nai, Phayathai
Bangkok, Thailand 10400

Cahan & Associates
818 Brannan St., Suite 300
San Francisco, CA 94103

Canary Studios
600 Grand Ave., Suite 307
Oakland, CA 94610

Command Z
1123 25th Ave.
Seattle, WA 98122

De Vale Design
8 South Michigan Ave., Suite 2212
Chicago, IL 60603

Debbie Kong Design
935 Ontario
Oak Park, IL 60302

Doink Inc.
P.O. Box 145249
Coral Gables, FL 33114

eandi design
1793 Lafayette St., Loft 200
Santa Clara, CA 95050

Eric Kass Design
11523 CherryBlossom East Drive
Fishers, IN 46038

Evenson Design Group
4445 Overland Ave.
Culver City, CA 90230

Firehouse 101 Art & Design
492 Armstrong St.
Columbus, OH 43215

FORM
1504 Aurora Ave., N., #308
Seattle, WA 98109

Fresh Design
5627 Cottonport Drive
Brentwood, TN 37027

Get Smart Design Company
899 Jackson St.
Dubuque, IA 52001

Glyphix Studio
21280 Erwin St.
Woodland Hills, CA 91367

Grafik Communications, Ltd.
1199 N. Fairfax St., Suite 700
Alexandria, VA 22314

Greenberg Kingsley, Inc.
95 Horatio St. 6W
New York, NY 10014

Greteman Group
142 N. Mosley
Wichita, KS 67202

GSD&M Advertising
828 W. Sixth St.
Austin, TX 78703

Gunnar Swanson Design Office
2213 Dunedin Ave.
Duluth, MN 55803

Hal Apple Design & Communications, Inc.
1112 Ocean Drive, Suite 203
Manhattan Beach, CA 90266

Images Graphic Design
P.O. Box 222, The Lake House on Main St.
Grafton, VT 05146

Janet Hughes and Associates
Three Mill Road, Suite 103
Wilmington, DE 19806

Joe Miller s Company
3080 Olcott St., Suite 210A
Santa Clara, CA 95054

John Brady Design Consultants, Inc.
Three Gateway Center, 17th Floor
Pittsburgh, PA 15222-1012

John Havel
2229 N. Mitchell
Phoenix, AZ 85006

Kiku Obata & Company
5585 Pershing, Suite 240
St. Louis, MO 63112

Kilmer & Kilmer, Inc.
125 Truman NE, Suite 200
Albuquerque, NM 87108

Knuckle Sandwich
1131 E. Coral Gables
Phoenix, AZ 85022

Leslie Evans Design Associates
81 W. Commercial St.
Portland, ME 04101

Lo Schiavo Design Group
Rua Desembarga dor Vicente Penteado, 311
São Paulo, Brazil 01440-030

Louey/Rubino Design Group Inc.
2525 Main St., Suite 204
Santa Monica, CA 90405

Madeleine Corson Design
25 Zoe St.
San Francisco, CA 94107

Mark Designs
10780 Rochester Ave.
Los Angeles, CA 90024

Mitten Design
604 Mission St., #820
San Francisco, CA 94105

mmm . . . funkalicious advertising
444 Francisco St., #202
San Francisco, CA 94133

The Moderns
900 Broadway
New York, NY 10003

Morrison Design & Advertising
2001 Sul Ross
Houston, TX 77098

neo design
1048 Potomac St., NW
Washington, DC 20007

Oh Boy, A Design Company
49 Geary St., Suite 530
San Francisco, CA 94108

Phinney/Bischoff Design House
614 Boylston Ave., East
Seattle, WA 98102

Salvato, Coe and Gabor
2015 W. 5th Ave.
Columbus, OH 43212

Sayles Graphic Design
308 Eighth St.
Des Moines, IA 50309

Scott Hull Associates
68 E. Franklin St.
Dayton, OH 45459

SEGURA INC.
1110 N. Milwaukee Ave.
Chicago, IL 60022-4017

Smart Works Pty Ltd
113 Ferrars St.
Southbank, Victoria, Australia 3006

Sommese Design
481 Glenn Road
State College, PA 16803

Stewart Monderer Design, Inc.
10 Thacher St., Suite 12
Boston, MA 02113

Studio Lumen
21 De Abril, 301 Alto Da XV
Curitiba, Parana, Brazil

TeamDesign
1809 Seventh Ave., Suite 500
Seattle, WA 98101

Tharp Did It
50 University Ave., Suite 21
Los Gatos, CA 95030

Thilo von Debschitz
Q Design
Neuberg 14
65193 Wiesbaden, Germany

Timbuk 2 Design
2475 Euclid Crescent East
Upland, CA 91784

Tom Varisco Designs
1925 Esplanade Ave.
New Orleans, LA 70116

Toni Schowalter Design
1133 Broadway, Suite 1610
New York, NY 10010

Van Dyke Company
85 Columbia St.
Seattle, WA 98104

Visual Marketing Associates
322 South Patterson Blvd.
Dayton, OH 45402

Viva Dolan Communications & Design
1216 Yonge St.
Toronto, Ontario M4T 1W1
Canada

Wexner Center for the Arts
1871 North High St.
Columbus, OH 43210-1393

White Design Marketing & Communications
4510 E. Pacific Coast Hwy., Suite 620
Long Beach, CA 90804

Zimmermann Crowe Design
90 Tehama St.
San Francisco, CA 94105

Zubi Design
57 Norman Ave. #4R
Brooklyn, NY 11222

Copyrights and Permissions

P. 12 © Grafik Communications, Ltd.
P. 13 © Lo Schiavo Design Group
P. 14 © Wexner Center for the Arts
P. 15 © BlackBird Creative
P. 16 © Cahan & Associates
P. 17 © Smart Works Pty Ltd
P. 18 © Hal Apple Design &
 Communications, Inc.
P. 19 © SEGURA INC.
P. 20 © Grafik Communications, Ltd.
P. 21 © Grafik Communications, Ltd.
P. 22 © Smart Works Pty Ltd
P. 23 © Cahan & Associates
P. 24 © neo design
P. 25 © White Design Marketing &
 Communications
P. 26 © Leslie Evans Design Associates
P. 27 © Mark Designs
P. 28 © Wexner Center for the Arts
P. 29 © Smart Works Pty Ltd
P. 30 © Cahan & Associates
P. 31 © Doink Inc.
P. 32 © Scott Hull Associates
P. 34 © Blind Co., Ltd.
P. 35 © AERIAL
P. 36 © Cahan & Associates
P. 37 © Zimmermann Crowe Design
P. 38 © BlackBird Creative
P. 38 © Mitten Design
P. 39 © Knuckle Sandwich
P. 40 © eandi design
P. 41 © Sayles Graphic Design
P. 42 © Blind Co., Ltd.
P. 43 © Greteman Group
P. 44 © Andrew Lewis Design
P. 45 © Mark Designs
P. 46 © AERIAL
P. 47 © Lo Schiavo Design Group
P. 48 © Glyphix Studio
P. 49 © Zimmermann Crowe Design
P. 50 Blind Co., Ltd.
P. 52 © Wexner Center for the Arts
P. 53 © After Hours Creative
P. 54 © Tom Varisco Designs
P. 54 © Images Graphic Design
P. 55 © Zimmermann Crowe Design

P. 56 © Sayles Graphic Design
P. 57 Joe Miller s Company
P. 58 © FORM
P. 59 © Lo Schiavo Design Group
P. 60 © Wexner Center for the Arts
P. 61 © Images Graphic Design
P. 62 © Oh Boy, A Design Company
P. 63 © Kiku Obata & Company
P. 64 © Janet Hughes and Associates
P. 65 © Greenberg Kingsley, Inc.
P. 66 © Grafik Communications, Ltd.
P. 68 © neo design
P. 69 © Toni Schowalter Design
P. 70 © Scott Hull Associates
P. 71 © White Design Marketing &
 Communications
P. 72 © Hal Apple Design &
 Communications, Inc.
P. 73 © Get Smart Design Company
P. 74 © Kilmer & Kilmer, Inc.
P. 75 © neo design
P. 76 © Stewart Monderer Design, Inc.
P. 77 © Smart Works Pty Ltd
P. 78 © Tharp Did It
P. 79 © Morrison Design & Advertising
P. 80 © Hal Apple Design &
 Communications, Inc.
P. 81 © Canary Studios
P. 82 © Timbuk 2 Design
P. 83 © aire design company
P. 84 © Evenson Design Group
P. 85 © Eric Kass Design
P. 86 © Greteman Group
P. 87 © Fresh Design
P. 88 © Images Graphic Design
P. 89 © neo design
P. 90 © De Vale Design
P. 92 © Eric Kass Design
P. 93 © Studio Lumen
P. 94 © Wexner Center for the Arts
P. 95 © Wexner Center for the Arts
P. 96 © Sayles Graphic Design
P. 97 © Kilmer & Kilmer, Inc.
P. 98 © Command Z
P. 99 © Sommese Design
P. 100 © Gunnar Swanson Design Office

P. 101 © Gunnar Swanson Design Office
P. 102 © Sommese Design
P. 103 © Cahan & Associates
P. 104 © Sayles Graphic Design
P. 106 © Viva Dolan Communications &
 Design
P. 107 © Madeleine Corson Design
P. 108 © GSD&M Advertising
P. 109 © Thilo von Debschitz & Laurenz
 Nielbock GbR
P. 110 © Firehouse 101 Art & Design
P. 111 © Firehouse 101 Art & Design
P. 112 © BlackBird Creative
P. 112 © GSD&M Advertising
P. 113 © Phinney/Bischoff
P. 114 © Van Dyke Company
P. 115 © The Moderns
P. 116 © Grafik Communications, Ltd.
P. 117 © Viva Dolan Communications &
 Design
P. 118 © Madeleine Corson Design
P. 119 © Madeleine Corson Design
P. 120 © John Brady Design Consultants,
 Inc.
P. 120 © John Brady Design Consultants,
 Inc.
P. 121 © Louey/Rubino Design Group Inc.
P. 122 © GSD&M Advertising
P. 124 © Command Z
P. 125 © Lo Schiavo Design Group
P. 126 © Mitten Design
P. 127 © Mitten Design
P. 128 © Debbie Kong Design
P. 129 © SEGURA INC.
P. 130 © Greteman Group
P. 131 © After Hours Creative
P. 132 © Command Z
P. 133 © Zubi Design
P. 134 © mmm . . . funkalicious advertising
P. 135 © Studio Lumen
P. 136 © Zimmermann Crowe Design
P. 137 © TeamDesign
P. 138 © John Havel
P. 139 © Zubi Design